# SECRET
# HIGH WYCOMBE

## Eddie Brazil

AMBERLEY

First published 2017

Amberley Publishing
The Hill, Stroud
Gloucestershire, GL5 4EP

www.amberley-books.com

Copyright © Eddie Brazil, 2017

The right of Eddie Brazil to be identified as the
Author of this work has been asserted in accordance
with the Copyrights, Designs and Patents Act 1988.

ISBN  978 1 4456 6530 6 (print)
ISBN  978 1 4456 6531 3 (ebook)

British Library Cataloguing in Publication Data.
A catalogue record for this book is available from the
British Library.

Origination by Amberley Publishing.
Printed in Great Britain.

# Contents

# Introduction

There is a great misconception about High Wycombe. Years of sarcastic putdowns by unfunny comedians and barbed one-sided observations by social commentators have painted the town in an altogether unflattering light – the archetypal provincial place where nothing important or exciting has, does, or will happen. The flaming cheek of it; how dare they? The truth of the matter is that these know-nothings have probably never stepped a foot in Wycombe, and are ignorant of its history, let alone where to find it on a map. Theirs is a typical reaction to a hackneyed viewpoint. If only those smug critics took the time to look a bit more deeply into the town's past, they would find a place of infinite interest and variety.

The history of High Wycombe goes back over a thousand years. It has played host to royalty, experienced the blood and mayhem of battles, and counted politicians, writers, artists, musicians and one of the founding fathers of the United States as one-time residents. The old adage that Wycombe is a town of churches, children and chairs is not even half the story.

In 1799, the town was the birthplace of the British army's officer training corp. It was represented at Westminster by one of Britain's greatest politicians. During the Second World War, it played a significant and crucial role in the defeat of Nazi Germany and, even though the Windsor chair is no longer made in the town, Wycombe is still the spiritual home of Britain's furniture industry. A place where nothing happens? I don't think so.

Of course, there may be many readers who will be already familiar with Wycombe's past, secret or otherwise. However, I have chosen to concentrate on those lesser-known facts about the town's past, so you will find little reference to the furniture industry or paper mills. Yet, throughout these pages, I believe the most ardent of the town's historians will find something new, intriguing and fascinating. Ultimately, this is a celebration of High Wycombe's secret history. For those old, new or visiting residents I hope reading the book makes you look at the town through new and, might I say, proud eyes.

I have taken the liberty of expanding the town's boundaries over a wide range. From Holtspur in the east to West Wycombe in the west; Handy Cross in the south across to Holmer Green in the north. Throughout the book I have referred to histories and locations outside of Wycombe. To tell the story of secret Wycombe outside the context of a wider English history would be confusing to the reader. Our journey through Wycombe's obscure story will start in the dim and distant past and move chronologically through to the present day. So, for all those mirthless stand-up comics and caustic commentators who think they know High Wycombe, read on.

# 1. Ancient Wycombe

## What's in a Name?

Before we step back into the town's misty beginnings, perhaps we should first ask how Wycombe acquired its name. This is a subject of some confusion and no small debate, which is not surprising given the town's centuries-old past. According to the *Oxford Dictionary of English Place Names* the first reference of what would become High Wycombe is recorded in AD 799, during the middle Saxon period of English history, as Wichama, meaning 'dwellings by the stream'. Old English *wic* and *ham* probably have the same denotation – settlement, village or home. However, *wic* is also thought to be an Anglo-Saxon word borrowed from the Latin word *vicus* meaning 'farm', and in particular, 'dairy farm'. Yet, other sources suggest that 'Wichama' also means a Romano-British village. This is not surprising as we know that the Romans occupied the valley of the Wye and even built a villa on what would become the Rye. For them the name might well have meant 'the British village by the stream where the cows graze'.

By 970, however, Wichama had become Wicumun. The word *cwm* is Brythonic or British and means 'combe' or 'valley'. The 'dairy farm by the stream in the valley', would be a fair description. Following the departure of the Romans from Britain in the fifth century, and the arrival of the Anglo-Saxons, Romano-British communities still dwelt in the Chilterns. Indeed, local place names such as Penn, Wendover and Chalfont are all Brythonic and not Anglo-Saxon.

After all of this one might be excused in wondering where the River Wye comes into the equation. No doubt the stream in the title refers to a water source that would later become the River Wye. It would appear that the river takes its name from the settlement and not the other way around. By 1086, the hamlet was known as Wicumbe. By 1220, a 'y' replaced the 'i' and it became Wycumbe. Incredibly, for a river that would help bring commerce and prosperity to Wycombe, the name of the Wye does not appear before 1810. It rises in West Wycombe and flows 9 miles to the River Thames at Bourne End.

By the fourteenth century the town is referred to as Cheppyng (meaning 'market') Wycombe, or East Wycombe. Subsequently, it would be recorded as 'Great Wycombe, Temple Wycombe, and finally, as we know it today, High Wycombe'. What had begun as Wichama, the dwellings by the stream, has evolved into the valley of the Wye high above the Thames.

However, before we move on, or back into the past, we must confuse the subject of names and places just a little more. Just as Wycombe has had numerous changes of title and moniker down the years, so too has the area in which it is situated.

High Wycombe sits in a valley of the Chiltern Hills, which stretches some 46 miles from Bedfordshire in the north to Goring, Berkshire, in the south. The name Chiltern supposedly comes from 'Cilternsaetan' (the folk of the Chilterns), a tribe that occupied the area in the early Anglo-Saxon period. However, this may not be the full story as another

source suggests that the name Chiltern is far more ancient and means 'the land beyond the hills'; a romantic, almost Tolkienesque, description. At the end of the day there is most likely a more down-to-earth, prosaic meaning probably used by all dwellers and travellers who came by way of the hills; for Chiltern simply means 'a chalky place'.

Part of the Chilterns is also an area within the county of Buckinghamshire. The name is Anglo-Saxon in origin (Buccingahamm) and means the district (*scire*) of Bucca's home. Bucca was an Anglo-Saxon thane or freeman. Just to further muddy the waters of comprehension, although the county has been thus named since around the twelfth century, it had existed as a division of the Kingdom of Mercia since the late sixth century. Mercia was one of the seven early established kingdoms of Anglo-Saxon England, known as the heptarchy. Along with Wessex and Northumbria, it gradually rose to prominence, and covered an area from the River Mersey in the north to the Bristol Channel in the south and London in the east.

If you are wondering why the term County of Buckinghamshire is also used, we must blame the Normans. Following the Norman Conquest, the French victors set about reorganising the administration of their newly won land. The Anglo-Saxon system of shires was unique and hard for the invaders to comprehend so they resorted to calling them counties, which is derived from the French practice of land and administration under the jurisdiction of a count.

Some 600 years before the Saxons held sway in England, Wichama was but an insignificant backwater in the land of Britannia (or, if you want to be utterly pedantic, Albion – the white land, no doubt christened by the first sea travellers who saw the cliffs of Dover), a province of the Roman Empire. However, some 400 years before the triumphant legions arrived on our shores, the settlement that would become Wiccumun,

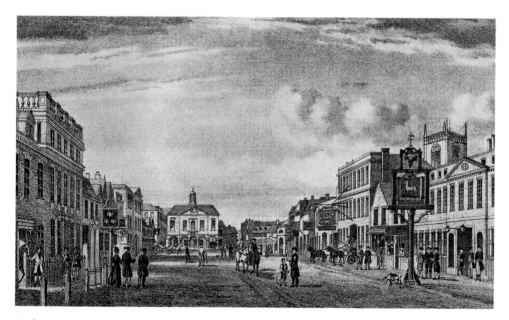

High Wycombe High Street in an eighteenth-century drawing.

was in the territory of the Catuvellauni. They were one of many ancient, Celtic tribes who occupied the southern part of Britain and included modern-day Buckinghamshire. If you, dear reader, had been resident in Wycombe 2,000 years ago, you could have counted yourself as one of the Catuvellauni.

Yet, long before the dairy farmers of Wichama had established their village, and way back before the Saxons, the Romans, the Catuvellauni, or even Wycombe Council held sway over the district, we know that the valley of the Wye had been travelled and inhabited for thousands of years by prehistoric man.

## Early Inhabitants

The evidence of Stone Age cultures, in what would become Wycombe, has been discovered in what we might think as the most ordinary of locations. A Palaeolithic (Old Stone Age) flint hand axe was found in a garden of a house on Rectory Avenue, near the centre of town. Old Stone Age and Middle Stone Age flint blades have been unearthed in West Wycombe Park. Mesolithic finds have also been discovered at Wycombe Abbey School, Micklefield, Sands, Daws Hill, and Terriers. During the construction of the Wycombe railway, in 1901, a Neolithic flint mine was unearthed close to where the station would be built.

These early people were nomadic hunter-gatherers who foraged and hunted for food and sustenance as they continued on their cyclical journey through the landscape. Part of their annual sojourn would have taken them through the valleys of the Chilterns, where they would stop off at selected sites to give thanks for whatever practical or spiritual help the landscape provided, before moving on.

The introduction of agriculture around 5000 BC freed the nomads from their arduous, annual trek. Now they could grow crops and harvest the earth. But more importantly, they could settle and remain in their chosen location establishing farms and communities. The well-watered valley of the Wye would have appealed to these early farmers. Without a doubt, thousands of years before Wichama was ever thought of, Stone Age man had set up his home in what would become High Wycombe.

Around 2500 BC we see the arrival of the Beaker People. They were itinerant traders who arrived on our shores from mainland Europe, so named for their use of characteristic bell-shaped cups. Although initially only few in number, they seem to have quickly gotten the upper hand on their Neolithic landlords, becoming a sort of nouveau aristocracy. They were farmers and archers, wearing stone wristguards to protect their arms from the sting of the bowstring. They were also the first metalsmiths in Britain, working first in copper and gold, and later in the bronze that would give its name to this era. Evidence of their presence in Wycombe has been discovered on the Rye in the same location where the Romans would construct a villa some 2,000 years later.

Late Neolithic and Bronze Age burial mounds (barrows) have been unearthed at Desborough Castle, Castle Hill House, on Priory Avenue, and West Wycombe Park. In the nineteenth century a Bronze Age cremation site containing urns and incense cups was found at the aptly named Barrow Croft, Meadway, in Wycombe Marsh. In 1932 further evidence of Bronze Age people in Wycombe was found near to Gomms Wood.

Curiously, the Bronze Age period also saw the proliferation of stone circles in Britain. Although circles may have been erected as early as 3400 BC, the Beaker Folk and their

descendants took over or adopted many of the beliefs and customs of the earlier Neolithic inhabitants. Certainly, they set out to improve the most famous of all stone circles, Stonehenge. It was built sometime around 2800 BC and initially consisted of nothing more than a ditch and bank enclosing an open space. Around 2200 BC, probably to impose their superiority on the local population, the Beaker People began the process of building a double ring of stones inside the henge, and it's this Stonehenge that we see today. But is it possible these itinerant traders from across the sea had similar plans for a sacred site in Wycombe?

The summit of West Wycombe Hill stands within the ramparts of an Iron Age hill fort that looks out over the grand sweep and roll of the Chiltern Hills. Yet, the site has been continuously occupied for thousands of years. A Bronze Age settlement is widely believed to have first existed on the hill, and research has shown that a Pagan temple was constructed in a similar style to Stonehenge. Was this the Beakers People's legacy to the folk of Bronze Age Wycombe?

Undoubtedly, West Wycombe Hill became a place of sacred significance, for a settlement and religious temple was constructed during the Roman occupation. The hill retained its religious importance and the first Christian church was erected in AD 635. And even today the Church of St Lawrence remains, looking out over a landscape that would still be familiar to Wycombe's earliest settlers.

Over the following 1,000 years, Britain was to see a further influx of migrant arrivals. These newcomers would bring with them a common tongue, a shared cultural heritage and introduce advances in metalworking technology, which would give the epoch a new name – the Iron Age.

The Iron Age in Britain is thought to have lasted from around 800 BC to the arrival of the Romans in 55 BC. In that time the country had become settled by a patchwork of neighbouring Celtic tribes who continuously competed with each other for dominance and supremacy. Included among them were the Iceni, who controlled what is now modern-day Norfolk and Suffolk. On the south-east coast the Canti held sway, from whom the county of Kent takes its name. Up on the north-east coast, near modern-day Lincolnshire, was the territory of the Parisi. It is believed that one day they upped sticks and sailed down the North Sea, across the English Channel and along the River Seine to found the city that still bears their name – Paris.

In central-southern Britain, an area comprising Hertfordshire, Bedfordshire, Cambridgeshire and Buckinghamshire, including what would become Wycombe, was the territory ruled by the Catuvellauni. They were a fierce, spiked, or long-haired warrior race who painted their bodies in blue woad and charged into battle on foot or mounted on armoured war chariots – the name Catuvellauni means, 'great in battle'. Their original capital was based at Wheathampstead in Hertfordshire, yet evidence of their presence has been discovered all over Buckinghamshire, including High Wycombe.

In 55 BC, under King Cassivellaunus, they expanded their territory by defeating their neighbouring tribes, the Trinovantes, who ruled what would become Essex, and the Attrebates, who controlled Berkshire and Wiltshire. Alarmed at the rise of the British tribe, Roman general, and soon to be emperor, Julius Caesar duly responded by crossing the channel with 10,000 men, but his army was met by a coalition of tribes under the leadership

of Cassivellaunus. Caesar records that he achieved victory over Cassivellaunus and his allies, but then made the odd decision to return straight to Rome leaving things pretty much as they were and the Catuvellauni still in control of the southern half of the country.

It would be almost a hundred years later that the Romans would once again attempt to conquer Britain. In that time, the Catuvellauni, under King Cunobelinius, the grandson of Cassivellaunus, had expanded their domains north towards Lincolnshire.

In AD 40, Caractacus, the son of Cunobelinius, became king and continued the strategy of subjugating the other British tribes. It was a military policy not lost on the Romans, who were increasing alarmed by the battle-hardened Catuvellauni across the Channel. In AD 43, Emperor Claudius decided to check the aggression of the British tribe and crossed the sea at the head of 40,000 troops. Caractacus and his men were waiting for them. Their bodies painted in blue woad and battle ready on their scythe-wielding chariots, they engaged the Romans in a bloody two-day struggle. It was a vicious affair with no quarter given. Yet, gradually the legions began to gain the upper hand and forced the Catuvellauni back. Caractacus organised line after line of defence, testing the Roman generals in a succession of battles, which cost the legions considerable losses. Still the Romans advanced, and still Caratacus and his people fought on. They were eventually driven back to their territory where they gave their last stand and were finally defeated.

It would seem that such accounts of epic, valiant and bloody history as this are as remote and fantastical from us in modern-day Wycombe as a forgotten chapter from Tolkien's Middle Earth. Yet evidence of the Catuvellauni people is still to be discovered around the town.

The hill fort at West Wycombe was undoubtedly occupied by the Catuvellauni, as was Desborough Castle, although archaeological evidence suggests it was mainly occupied during the Middle Ages. These forts, along with similar defensive sites in south Bucks, are thought to have been linked along the Chiltern escarpment on the line of a prehistoric track connecting to the ancient Icknield Way, which runs for over 100 miles from Norfolk to Wiltshire. The hill fort at Medmenham on the Thames probably marked the border of Catuvellauni territory with the neighbouring Atrebates tribe.

In recent years, archaeologists have speculated that Totteridge, a northern suburb of Wycombe, but at one time an independent village, might be the site of an Iron Age hill fort. Early nineteenth-century maps of the area indicate 'Totteridge Castle'. This would not have been a castle in the traditional style of walls and battlements, but probably a defensive structure similar to Desborough Castle on the south side of Wycombe. Kingswood, which overlooks the Micklefield Valley, contains an earth-and-bank ditch of Iron Age character. It is entirely possible that Celtic tribes would have inhabited the northern slope of the Wye Valley.

A symbol of the power and dominance of the Catuvellauni is found some 7 miles east of Wycombe, just outside the town of Gerrards Cross. Here stands Bulstrode Camp, the largest hill fort in Buckinghamshire. It covers an area of 27 acres and consists of a double rampart and inner and outer ditches and was occupied by the Catuvellauni around 200 BC. Perhaps the most compelling evidence of the Celtic tribe's occupation of Wycombe was discovered in 1826 when coinage from the reign of the Catuvellaunian King Tasciovanus (20 BC–AD 10) was unearthed on Keep Hill near the Rye.

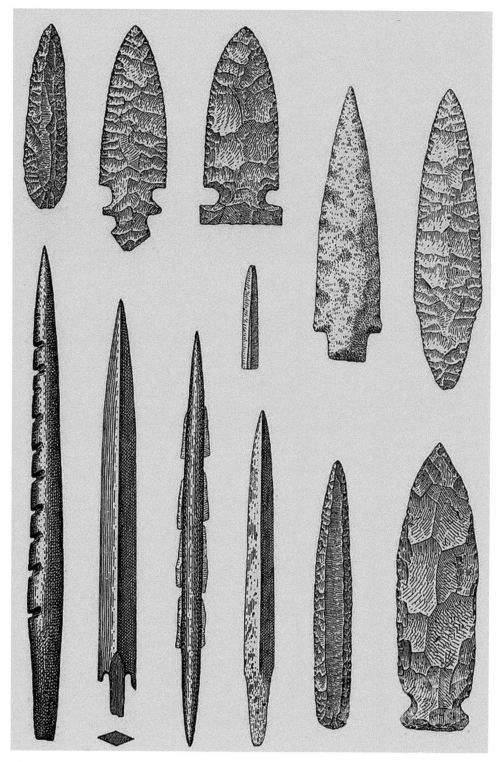

Flint arrowheads.

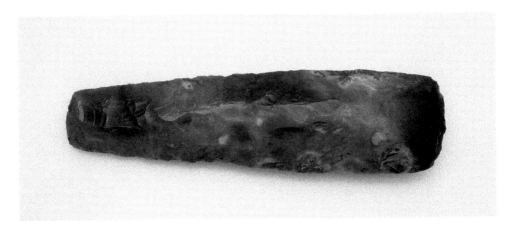

Flint axe head.

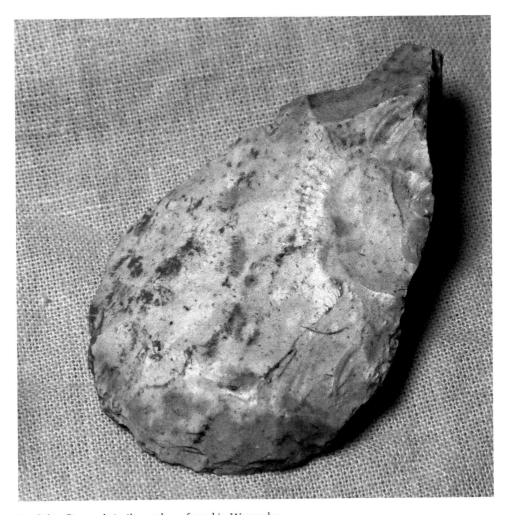

Neolithic flint tool similar to those found in Wycombe.

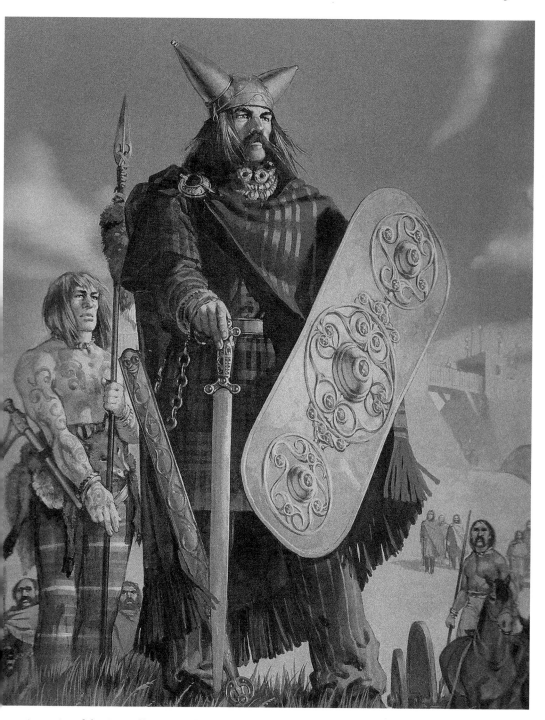

A warrior of the Catuvellauni people.

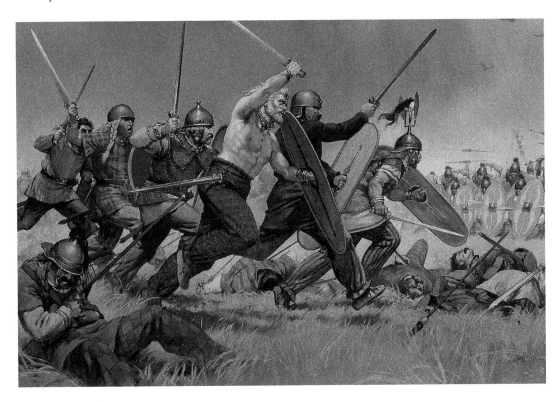

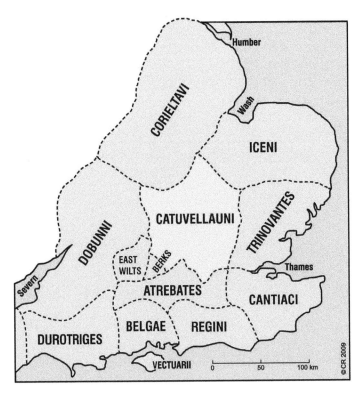

*Above*: Celtic warriors charge into battle.

*Left*: A map of southern Britain showing the territories of the Celtic tribes.

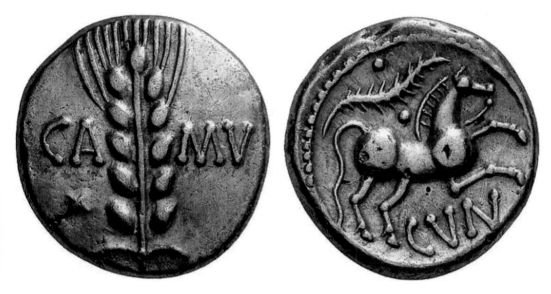

Catuvellauni coinage similar to that found on Keep Hill.

However, a new military dawn was rising. Despite their renown for being 'great in battle', the Catuvellauni would, like Britain's other Celtic tribes, eventually have to submit to the power of the legions of Rome.

## The Romans

It may seem odd, even hard to believe, that as we trudge our way to work through a wet Wycombe weekday, or sit frustrated in a never moving traffic jam en route to another miserable day at the office or factory, that 2,000 years ago the Romans travelled and settled in this very same valley.

The invasion of Britain by Emperor Claudius in AD 43 swept all before it. Those remaining Catuvellauni who remained in the Wye Valley and had not fled into the west, reluctantly succumbed to the Roman thumb. Those who left may have used the ancient track known to history as the British Way, which roughly follows the line of the present-day Crendon Street up and out of the valley.

But the Romans were here to stay, at least for the following 400 years. Evidence of their occupation was first discovered in 1724, when workmen from the Wycombe Abbey estate discovered a Roman mosaic floor on the Rye. Yet it is probable that the site was known in medieval times, as Roman tiles were used in the eleventh-century construction of the Hospital of St John the Baptist in Easton Street, and can still be seen today.

It was thought, initially, that the site was a Roman military station dating from AD 150, and for years this interpretation persisted. On early Ordnance Survey maps the site and its location on the Rye were referred to as 'The Fortress'. Curiously, despite its obvious historical importance, no excavations took place and the site was soon forgotten. However, in 1863 the site was rediscovered, and what was identified as a villa complex was partly excavated. It would be another sixty-eight years before archaeologists returned to the

Rye to re-examine the villa. They found evidence or a hypocaust, baths, and outbuildings. There is no doubt that the villa was of a high status and has been recorded as the largest in Buckinghamshire.

It is not only on the Rye that evidence of the Romans has been discovered. Roman coins have been found on Desborough Road, Totteridge Road, and even along the line of the railway. In 1929, a Roman pit containing pottery and animal bones was discovered at Terriers. During the nineteenth century a Roman well, floors and walls were discovered on Castle Street in the centre of the town. Further Roman building foundations were unearthed during the construction of the Methodist Chapel opposite the Rye. Perhaps a most unlikely Roman location is found along Micklefield Road where a second-century farmstead has been identified. Altogether, it would appear that the Roman presence in Wycombe extended over much of the present-day town.

And yet, just as prehistoric man, the Beaker People, and the Catuvellauni had their time in the Wye Valley, 400 years after their triumphant arrival, the clock was ticking for the Romans. Barbarian raids on the eternal city had forced the legions to return home. Britain was left to defend itself from the heathens invading from Scandinavia and Germany. The English were coming.

Roman legions on the march.

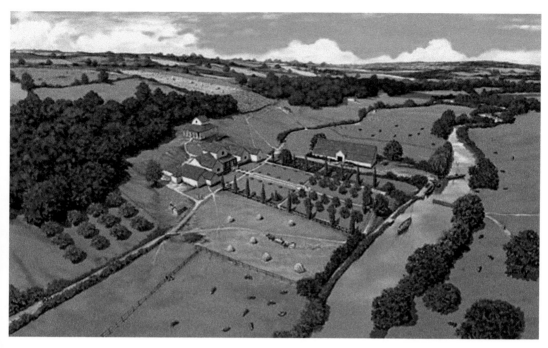

This is what the villa on the Rye might have looked like during the Roman occupation of Wycombe.

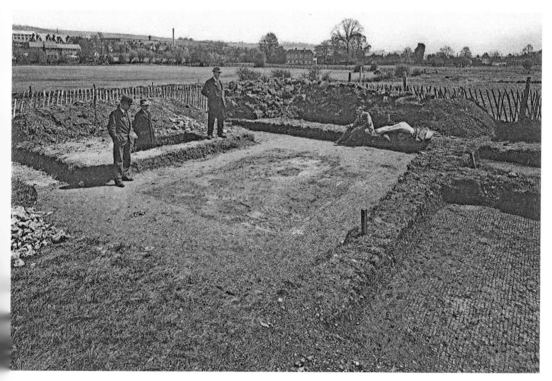

In the 1930s archaeologists excavated the villa on the Rye.

## The Anglo-Saxons

The departure of the Romans in AD 450 left a power vacuum in Britain. Raiders from across the Irish Sea and marauding Picts streaming across Hadrian's Wall vied with one another to gain control of the old Roman province. Tradition has it that the Romano-British leader Vortigen called on the help of two Anglo-Saxon mercenaries, Hengist and Horsa, to aid him in his quest to hold back the invading forces. The Saxons duly put the Scots and Irish to flight but then took a look around and saw what a beautiful, and more importantly rich, land Britannia was and decided they would stay. Word was sent back to their kinsman across the North Sea, and soon waves of Angles, Saxons and Jutes arrived on Britain's shore. The rest they say is history. A new nation, language and culture was born – 'Angle land'. And yet, for the next 200 years, whoever dwelt, farmed and travelled the area of the Wye Valley would become lost in the fog of the Dark Ages.

It would appear from archaeological evidence that these early Saxons did not initially penetrate far into the Chilterns. The heavily wooded hills were not to their liking, and it is possible there were still Romano-British enclaves still in existence. As mentioned earlier, local place names such as Penn, Wendover, and Chalfont are all British in origin. Those Celts who had not fled west into Wales or Cornwall remained, and possibly still occupied the settlement that would become Wichama/Wycombe. Some archaeologists and historians have speculated that the name 'Crendon', as in Crendon Street in the centre of Wycombe, might refer to a British chieftain, Creona. The early Anglo-Saxon word *don*, meaning 'hill', was probably applied to identify 'Creona's hill', a last vestige of the Romano-British in the Wye Valley.

It must have been an uneasy time for the native British as the early Saxons were pagans who practised blood sacrifice. In many Saxon graves, particularly those of warlords or chieftains, the remains of females have also been discovered. These were found to be young women prompting the theory that they were ritualistically killed to accompany their spouse into the next world.

The earliest evidence for Saxon Wycombe comes from the discovery of a burial in the grounds of Castle Hill House in Priory Avenue, thought to date from the fifth to the seventh century. The skeleton of a young woman unearthed from a barrow is believed to be that of a daughter of an Anglo-Saxon prince who had his base at Taplow, 8 miles south of Wycombe. Indeed, it is possible she was the daughter of the Saxon chieftain Taeppa. The village takes its name from Taeppa's burial mound, or *hlaw*. This was a burial of high status, containing grave items on a par with the famous barrow of the East Anglian King Raedwald, at Sutton Hoo in Suffolk. If the princess was indeed of royal blood, we may wonder why her last resting place was in Wycombe.

Further, Saxon burial sites have been discovered throughout Wycombe, in Micklefield, Wycombe Marsh, West Wycombe, Downley, Bourne End and Loudwater. During alterations to a sixteenth-century house in Church Square in the centre of Wycombe, a number of burials were unearthed lying in a confused state and interred in no particular order. They were laid in an area where the parish church would be founded some 400 years later and may be of significance to the development of All Saints as Wycombe parish church.

All Saints Church was constructed in the thirteenth century. However, there is debate as to whether Wycombe's church had been established earlier. The eleventh-century

dedication of All Saints by St Wulfstan suggests that Wycombe did not possess a church until the end of the Anglo-Saxon period. Yet, it has been argued that Wycombe's links to St Wulfstan and the bishopric of Winchester suggests that the origins of All Saints may well be much earlier, possibly as one of the first wave of churches founded during the conversion period from Paganism to Christianity in around 660–725.

The most prominent remaining evidence of Wycombe's early Saxon period is found just 2 miles north of West Wycombe, in woods near the village of Bradenham. Here, one can still follow part of the earth work known as Grim's Ditch. First mentioned in a twelfth-century document, it was originally thought that its construction was of Iron Age date, or from a period lost so far back in the mists of time it must have been built by 'Grim', an ancient word for the devil. Today, its remaining sections stretch from Mongwell in Oxfordshire, across the Chilterns, and onto Tring in Hertfordshire. Archaeologists are of the opinion that it is of an early Saxon date, and possibly constructed as an eastern boundary to the territory of the West-Saxon chieftain Cuthwulf. It was Cuthwulf who defeated the Britons at the Battle of Aylesbury in 571. He would go onto consolidate his power and prestige with further victories at Luton, Eynsham and Benson in Oxfordshire.

If the Saxons weren't putting the Britons to the sword, they were also fighting among themselves. Cuthwulf was a West Saxon, whereas Wycombe lay in the Kingdom of Mercia, the territory of the Middle Angles. If the ditch is, indeed, a boundary marking the extent of Cuthwulf's province then it was constructed for a good reason. For decades the Anglo-Saxons had fought each other for supremacy of England, and held onto their hard-won victories by either sword or defence. Yet, by 871 a new menace would appear in the land to force the English to bury their differences and join together for their own survival. The Vikings had arrived.

The Viking invasion of England in the ninth century swept all before it. By 878 the English had been forced back to a marshy island in Somerset. It was here that the most important battle in English history took place. In May 878, King Alfred the Great defeated the Danes at Edington. If he had failed, the Norsemen would have conquered the whole of the country and Britain would have become a Scandinavian kingdom. The inhabitants of Wycombe would be speaking Danish today.

Eventually, the Vikings were to be pushed back by the descendants of Alfred, and the whole of England was reclaimed. By the time Wycombe/Wichama is first mentioned in 970, King Edgar the Peaceful sat on the throne. It would appear that not all Norsemen came to rape and pillage. Curiously, three villages to the south-west of Wycombe, Fingest, Frieth and Skirmet, are all of Scandinavian origin, suggesting that some of the Danes who did not return to Denmark in their longships chose to settle in the Thames Valley.

However, just under 100 years after Wycombe was first recorded, the Vikings returned to England, this time as Normans. Norsemen had settled in northern France in the ninth century. Their victory at Hastings in 1066 and subsequent conquest of the country destroyed the old Anglo-Saxon kingdoms, but not England. The nation of England, its language, people and culture had been firmly established and would withstand, absorb and supersede its ruling, French speaking aristocracy, and the settlement known as 'Wicumun', was here to stay.

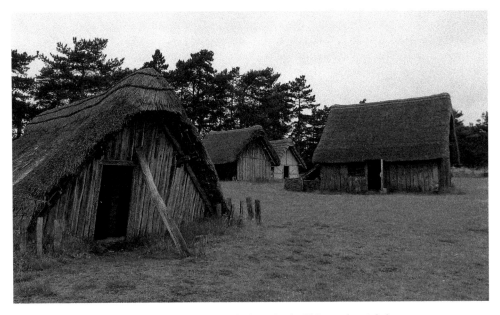

These thatched huts show what Wicumun might have looked like in the eighth century.

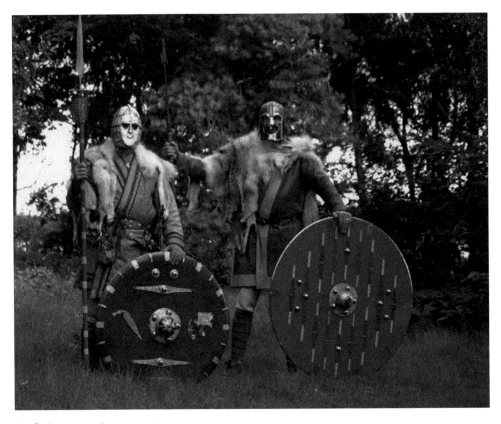

Anglo-Saxon warriors.

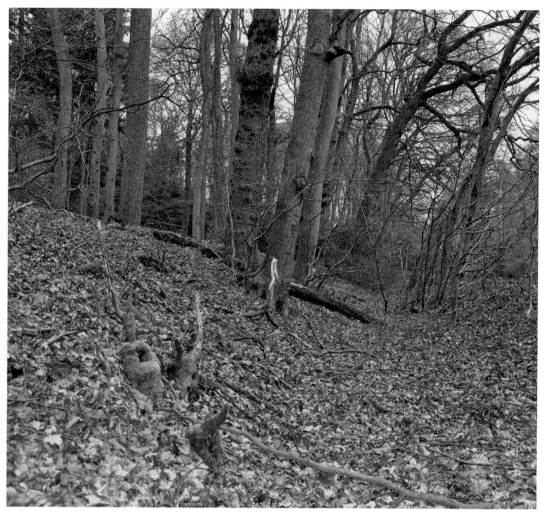

A part of the Grims Ditch near Bradenham. It was the boundary of Cuthwulf's territory.

## DID YOU KNOW?

English is the world's most widely spoken language. Over the last 1,700 years it has evolved, developed and changed into the tongue we speak today. However, if we could go back to the Wycombe of 799, the year the town was first recorded, we would hear the townsfolk speaking in English, but it would an English totally incomprehensible to our ears and sounding more like German. Even as late as the early fourteenth century, the English spoken in Wycombe would be hard for us to follow today.

## DID YOU KNOW?

In Western Australia there is a town called High Wycombe. It is situated near the city of Perth, and even has an industrial suburb called Hazlemere.

# 2. Mysterious Wycombe

## Sacred Wells

If a town has its secrets, it certainly also has its mysteries. One might say the two words are mutually interchangeable. Then again, it could be argued that they are also mutually destructive. Reveal the secret and we destroy the mystery. High Wycombe, given its long and distant past, is no exception, for its secret history is inextricably linked to its mysteries. But is that always the case? Take for example the enigma of Wycombe's secret sacred wells, which are said to lie buried beneath the modern town.

All we have today to remind us of these forgotten waterways are names. Perhaps the most well known is Holywell Mead. What were thought to be holy wells were in fact often springs, yet on Holywell Mead today there is no obvious sign of what we would recognise to be a well or a spring. To confuse the matter, a number of springs/ancient wells have been found in other parts of Wycombe, some of which have been proposed as being *the* holy well.

One such is Malmers Well, the name of which survives today as a road just off Amersham Hill. Malmers Well appears to have been applied to an earthwork rather than a well. In *Early History and Antiquities of Wycombe*, by John Parker, published in 1878, there is reference to the manuscripts of a Dr Willis, who visited Wycombe at the beginning of the eighteenth century. He writes:

> Above the church about four furlongs distant is a Celtic or British fortification called Mawtrim's or Manuck's Well, afterwards called Malmer's Well, about 300 yards from the Castle Hill, lying on the north side; it is round with entrances on the north and south sides and is bounded on the east and partly on the north by the ancient British road called Crendon Lane.

What Parker was describing was possibly not a well but an ancient burial chamber.

> In the year 1863, an excavation was made in Wycombe Cemetery which forms part of Malmers Well ... a pit was discovered, which may be described as a nearly circular chamber, 7 feet deep, 8 feet in diameter at the top and slightly tapering to a diameter of 6 feet at the bottom. These limits were well defined, the chalk having been sharply cut away all round and at the bottom. These limits were well defined, the chalk having been sharply cut away all round and at the bottom. The pit contained what was thought to be the remains of a cremation and it seems unlikely that the holy well was in the Malmers Well area.

This area of Wycombe seems to be abundant in ancient wells, for two were found in the vicinity of The Priory, a building on the corner of Castle Street and Priory Road.

The building used to be called Wellysbourne House, but this name apparently refers to the Wellysbourne family, whose residence it once was. Parker relates how 'in the garden in front of the house in All Hallows Lane [now called Castle Street], on the west was discovered a Roman well'. The well would now be under the pavement of Castle Street.

However, other well experts seem to think that Wycombe's holy well lays not under Castle Street but Priory Avenue. In a letter to the *Wycombe and South Bucks Star*, dated 3 February 1984, a correspondent writes:

> I think the holy well was in the centre of High Wycombe and not on Holywell Mead. In 1968 I was working at the top of Thame House office block when the Priory Road shopping area was being developed. Halfway up Priory Road on the right hand side was prefabricated building used, I think by Charrington Fuels. This was being demolished and the ground cleared when there was a great disturbance and a bulldozer or dumper truck almost went into a mammoth well unearthed in the old Priory Grounds...within a short time, less than a week, it had been buried again without trace and now lies under the floor of one of the Priory Road shops.

One more theory is that the holy well was literally in the centre of Wycombe. A correspondent to the *Star* newspaper in 1984 writes:

> As far as I know this [the holy well] was a shrine to the Virgin Mary, a place of pilgrimage, where pilgrims came to drink the waters which apparently had healing powers. This shrine was said to be in the area of St Mary's Street, Paul's Row, and Lily's Walk. Lily's Walk takes its name from the lady with the lily and you may be aware that many statues to this day depict the Virgin Mary holding a bunch of Lillies.

However, in his book *The Building of Wycombe Church*, published in the late nineteenth century, E. J. Payne states that the powerful spring, which, at that time, rose at the east end of Rye Common, and close to the site of the Roman villa, is indeed the holy well. It was so named in the Middle Ages, and today the adjoining meadow is known as Haliwell Mead. Significantly, the well was shown on an 1832 map as a marker of the municipal boundary of the borough of Chepping, or Market Wycombe, suggesting that the spring was of ancient importance. According to tradition the well was the site of sacred pilgrimages in the eleventh century and possibly connected with St Wulfstan. Sadly, the well now lies lost under the playing fields of the Rye.

We will return to St Wulfstan and the sacred wells in a moment. First, however, we must look at why such springs became holy and were chosen as the site of religious veneration.

As mentioned in chapter one of this book, the people of Mesolithic (Middle Stone Age, around 5000 BC) Britain were nomadic tribes. Their very existence depended on their understanding and awareness of not only nature but also the land and the seasons. They took their accustomed routes and stopped at familiar places. These places were marked by a natural feature such as a tree, a rock, spring or well where a spirit dwelt, and the nature of the spirit determined what should be done there. At certain places, other travelling groups were encountered leading to ceremonies and exchanges of gifts,

which later became festivals. Shrines or altars erected for worship to the spirit would, in times of inclement weather, be covered by a rudimentary shelter. This, in time, would become what we now recognise as the chancel of a church. Likewise, those worshippers who gathered for ceremonies would also construct a covering to protect them from the rain and wind. This would, in turn, become the nave. A place of worship was established, which would become the basis of the parish church.

When the Anglo-Saxons arrived in Britain in 450 they practised Paganism. Yet, in 597, Pope Gregory sent St Augustine on his mission to convert the heathen English to Christianity. Part of his mission was to absorb the pagan practises he found into Christian doctrine. The Christian church simply took over and 'Christianised' the ancient rituals, such as well worship. We can still see this today, in particular at Christmastime when we decorate our homes with holly and mistletoe, and more significantly in the Christian baptism where newcomers to the faith are immersed in water.

When E. J. Payne stated in his book that the holy well was located on the Rye, he may well have been directing the reader away from All Saints in the centre of Wycombe and the notion that the town's Christian parish church was originally a place of pagan well worship. Archaeologists have found both Celtic and Roman remains in the churchyard of All Saints. Yet, more tantalisingly, within a few feet of the east end of the church, well experts claim there is evidence of two ancient wells: one Roman, the other dating back further. Of course, the placement of Christian churches on places of Pagan worship is not unique to Wycombe. All over Britain's churchyards one can find reminders of earlier religious practises, such as Celtic crosses, preaching stones and the ever-present yew tree.

If All Saints was indeed the centre of well worship in Wycombe, then it all came to a stop in 1086 when the Bishop of Worcester, later to be canonised St Wulfstan, consecrated the church. Wulfstan came to live in Wycombe and, while in the town, a number of miracles were attributed to him. The first occurred when he was staying a friend's house, which, without warning, began to shake and crumble. The servants fled in panic from the doomed building, but Wulfstan remained convinced the house would not collapse. He was proved right, yet only temporarily. The servants were able to return to the building to collect their belongings. It was only after the bishop had left that the house came crumbling down.

The second miracle was when Wulfstan was again staying with a friend in the town and one night the servant girl became unwell. Her head was said to be horribly swollen and her tongue was enlarged to the size of an ox. The bishop was said to have a piece of gold pierced with the spear that had supposedly pierced the body of Christ. Wulfstan dipped the gold in consecrated water and gave it to the girl. Within days she was completely cured.

Of course, whether or not these miracles took place is impossible to say. What is interesting is that Wulfstan, in curing the servant girl, is said to have dipped the gold in consecrated water. Could this water have come from the spring or well that well experts believe lies somewhere beneath All Saints churchyard?

Curiously, 100 years after Wolfsan's death, Wycombe became a centre of pilgrimage connected with him. In his book, Payne maintains that the pilgrims flocked to a site on the Rye located near to today's Bassetsbury Manor. However, these revered visitations

were eventually curtailed by the church of the day, as it was said that 'abuses had taken place'. We may wonder what these were. It may well be that the church was uncomfortable with the idea that pilgrims were coming to Wycombe to give thanks at an ancient well on the Rye, and not at the church that St Wulfstan had consecrated. Then again the reason may also have been that paganism had once again raised its heathen head in the country.

During the calamitous reign of Ethelred the Unready (978–1016) the Vikings once more returned to England. This time they came not to settle but to burn and pillage. Such was the destruction meted out to the people that many of them abandoned Christianity and returned, in hopeful salvation, to their pagan idols.

Lastly, we must ask the question: did these sacred wells possess magical properties? Well yes, and no. Those prehistoric nomadic hunter-gathers who gave thanks to the water spirit that they believed dwelt with in the well or spring did so not just on a spiritual level, but also a practical one. Water was their lifeblood. Whatever helped sustain existence was to be revered. The Beaker People and the Romans chose to settle near to water sources because it was the sensible thing to do. The main reason Wycombe was established in its location is because it sits in a well-watered valley. But what of spiritual realities?

The well water in parts of Wycombe contains ammonia. In a diluted form this ammonia can be used as a disinfectant and cleaner. No doubt, to ancient peoples, such water would

A sacred well.

## DID YOU KNOW?

For 300 years, between 1665 and 1913, Wycombe had its own Quaker burial ground. It was situated along Easton Street at the rear of the ruins of St John's Hospital. The area is now a car park that extends up to Birdcage Walk. The Quakers, being Methodists, would have not have been granted everlasting peace in the graveyard of All Saints Church in the centre of town.

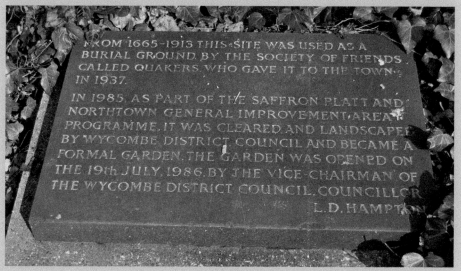

The site of the Quaker burial ground in Eastern Street.

have seemed holy and life-giving. However, perhaps the most curious aspect concerning water, especially a spring that flows underground, is that it produces changes in the magnetic field. It is known that certain people who possess mediumistic or extrasensory abilities are affected by changes in the magnetic field. It is possible that those ancient wanderers who came across the wells and springs as they travelled through the valley of the Wye were much more in tune with the supernatural than we are today. Such psychic vibrations emanating from the water of a well would have certainly seemed sacred.

## Flying Saucers Over High Wycombe

The notion that extraterrestrial life exists somewhere in the unfathomable vastness of the universe is often viewed with derision by scientists and with ridicule by sceptics. However, consider these facts: the farthest galaxy from Earth has been measured at 13 billion light years away; and the nearest star to our own planet is Proxima Centauri, at the relatively nearer distance of 4 light years. Yet, to travel there by the same propulsion and speed used in the Apollo moon programme would take 100,000 earth years. It has been estimated that there are 100 million galaxies, each containing a billion stars, around which a jaw-dropping one thousand, billion, trillion planets orbit. Given such eye-watering statistics, can we really say we are alone in the universe? It would seem that one person who was convinced that ET is definitely out there was a High Wycombe businessman by the name of William Robert Loosley. He claimed to have witnessed 'denizens from another world' – or did he?

One night in October 1871, Loosley was standing in his garden to get some fresh air after waking with a slight fever. The time was 3 a.m., and on looking at the sky he saw what he thought was a star, which seemed as if it was falling to earth with a great roar. In shock, he realised that the plummeting light was not a star but some kind of craft, whose trajectory would bring it down on Plomer Hill in Downley, west of the town centre.

The craft disappeared from sight within the dark folds of the hills, but Loosley did not hear any sound of an impact. The following day he set out to find evidence of the craft, which surely must have crashed to Earth. On reaching the site, Loosley found no sign of debris or evidence of any resulting fire, but did discover two unusually shaped metal objects that moved by themselves and made whizzing and whirring sounds. He says that they shone purple lights into his eyes where upon he could see amazing futuristic visions, including ghostly images of himself. Terrified, he fled the scene back to his home. Although he was totally shocked by what he had experienced, he nonetheless felt compelled to write down an account of the incident: 'An account of a meeting with denizens from another world.' However, he was also aware that if knowledge of what he saw was made public he would be ridiculed and his reputation sullied, so he decided to hide his written account of what we would today call a UFO in a secret draw of a desk.

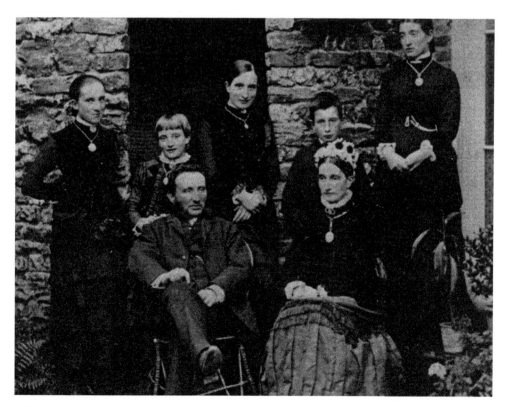

William Robert Loosley and his family.

And there it lay for a century, before being discovered by his great-great-granddaughter, Edith Salter. Mrs Salter passed the written account of the UFO onto the science journalist and sci-fi writer David Frankland, who was given permission to publish it in a book he was writing on flying saucers. Frankland was almost worried as much as Loosley that the account of the UFO would be debunked as the madness of a crank. He needn't have worried, for when the book was published in 1979, Loosley's story entered into UFO lore as an amazing and detailed account of what could only be explained as an alien visitation. And yet the truth of the matter is that the whole story was a fraud, perpetrated by Frankland as a practical joke played on believers and lovers of UFOs.

What is fascinating about Franklands hoodwink is that he chose to use an obscure High Wycombe business man as centrepiece of his charade. He goes as far as acknowledging Loosley's granddaughter for her help, includes photos acknowledging her, and also includes photos of Loosley's grave in Wycombe Cemetery, and one of his shop on Oxford Road taken in the 1880s, to lend substance to his story. Strangely, the incident is still considered by uninformed authors as a true, first-hand account of a UFO sighting.

## The Hellfire Club

No book about secret High Wycombe would be complete without reference to the infamous Sir Francis Dashwood and his notorious Hellfire Club. Many words have been written about what took place when Dashwood and his cronies, accompanied by their women and wine, descended into the labyrinth of caves that snake their way deep within West Wycombe Hill. Chinese whispers have added to the legend, and, no doubt, ensured its continual fascination today. It is probably Wycombe's most famous tourist destination; each year visitors from around the world come to see and learn what really went on down below.

Over the years, many myths and half-truths have attached themselves to the Baron le Despencer and the society he founded in 1749 – devil worship, Satanism, wickedness and depravity. By eighteenth-century moral standards such behaviour, if true, would no doubt be considered unacceptable, even downright evil. Yet today, we might view with it with no more thought or alarm from what we may encounter in the centre of High Wycombe on a Saturday night.

But the question remains: what was the real purpose and reason behind an eighteenth-century politician's need to indulge in such scandalous activities?

West Wycombe lies some 2.5 miles from the centre of High Wycombe along the A40. It is a pleasing location containing many fine half-timbered buildings dating from the fifteenth to the eighteenth centuries. Rising above the village looms West Wycombe Hill, a perfect place for the mysteries of Britain's pagan past. As mentioned earlier in this book, the site has been continuously occupied for thousands of years. A Bronze Age settlement is widely believed to have first existed here, and research has shown that a pagan temple was constructed in a similar style to Stonehenge. The Romans also built their own settlement and religious temple here.

During the Saxon period, the site became the village of Haeferingdune, the hill of Haefers people, a name which later evolved into Haveringdon. The village was greatly reduced by the Black Death in the fourteenth century, and by the early eighteenth century

the village had relocated to the valley along the Oxford Road and was subsequently renamed, due to its position west of the town of High Wycombe.

Today, no trace of Haveringdon village on the hill survives, although its parish church remains. With such an ancient and dark past, it seems appropriate that the one man who would become synonymous with West Wycombe took eagerly to the pleasures, rituals and rakish delights of eighteenth-century decadence.

In 1724, Sir Francis Dashwood (1708–81), 2nd Baronet, and later 15th Baron le Despencer, succeeded to the estate and set about remodelling the house, West Wycombe Park. Like many titled gentlemen of his day he embarked on the grand tour of Europe and returned to England with his own grandiose plans for West Wycombe. The house, built and added to between 1740 and 1800, was conceived as a pleasure palace for an eighteenth-century libertine. The building encapsulates the entire progression of British eighteenth-century architecture, from Palladian to neoclassical, and is set within a landscaped park containing temples and follies.

The baronet didn't limit his ideas and plans to just his home and gardens. In 1751, the fourteenth-century Church of St Lawrence disappeared within Dashwood's rebuilding of the interior, and the rebuild copied the third-century Temple of the Sun at Palmyra in Damascus. Only the medieval tower was retained, which itself was considerably heightened and topped by a great golden ball fitted with benches; it was large enough to contain six people. It was in the golden ball that Dashwood and his cronies drank the night away as they played cards and related bawdy stories. In 1765, the vast hexagonal Dashwood mausoleum was built east of the church. Its design was derived from the Constantine Arch in Rome, and it was where the Dashwood memorials would be erected.

Yet, of all Sir Francis grand schemes for West Wycombe, perhaps the most ambitious was undertaken between 1748 and 1752 with the extension of a series of ancient chalk tunnels under West Wycombe Hill into an elaborate labyrinth of caves and chambers. In order to provide work for the unemployed following a succession of harvest failures, Dashwood paid each labourer a shilling per day to excavate the passageways, which extended a third of a mile into the hill. Although it was a generous show of altruism, the baronet had other motives. The cave's design was much inspired by Dashwood's travels in the Mediterranean. The descent through the passageways and underground chambers concluded by crossing a subterranean river named the Styx, and entering into the inner temple, which is said to lie directly 300 feet below the Church of St Lawrence. According to Greek mythology, the River Styx separated the mortal world from the immortal world, and the subterranean position of the inner temple directly beneath Saint Lawrence's Church was supposed to signify Heaven and Hell.

Between 1763 and 1766, the Hellfire Club held their nefarious meetings in the caves below the hill, and it's from this period of the society's history that most of the clubs mythology has come from. However, it would appear that the caves at West Wycombe were really only part two of Dashwood's Hellfire Club story, for by the time the labyrinth under West Wycombe Hill resounded to midnight raucous laughter and the popping of corks, most of the original members were dead or dying and those still living had become disgusted with the club and begun to attack their former 'brothers'.

Before the recriminations began, the club held their drunken gatherings at the ruined Medmenham Abbey, situated on the banks of the River Thames, 8 miles south of West Wycombe. Here, they called themselves the Monks of Medmenham, and their numbers included artist William Hogarth, political activist John Wilkes, John Montague, 4th Earl of Sandwich, poet Paul Whitehead and possibly, at times, the American Benjamin Franklin.

It is uncertain what exactly the Hellfire Club members got up to during their twice-monthly meetings. They greeted each other as brother and dressed as monks, while their accompanying ladies were attired as virginal nuns. Possibly some form of Satanic or pagan ritual mimicry took place, but more likely they indulged in drinking, gambling and whoring. Following a practical jape played on the Earl of Sandwich during one of their drunken ceremonies, and his subsequent ridicule for believing that the materialisation of a monkey, jokingly released from a box by a fellow member, was the manifestation of the Devil, the club fell apart.

Following Dashwood's death in 1781 the caves fell out of use and became derelict. It was in the early nineteenth century that the subterranean passageways of West Wycombe Hill became the site of reported ghostly phenomena. When Paul Whitehead, a steward and secretary of the Hellfire Club and close friend to Sir Francis Dashwood, died his heart was placed in an elegant marble urn in the mausoleum, as his will requested. In 1829 it was allegedly stolen by an Australian soldier.

Yet the greatest mystery surrounding the Hellfire Club is, perhaps, Sir Francis Dashwood himself – a man of many contradictions. On the one hand he was said to have tremendous kindness, moral courage and a great fighter on the behalf of lost causes. Following a bad harvest, he provided employment for impoverished farm workers in West Wycombe. In an era that was riddled with political corruption, he managed to remain an honest, if not a very good, politician. Together with Benjamin Franklin, he produced the abridged *Book of Common Prayer*, which is still used today in churches across the United States.

Contrast this principled philanthropy with Dashwood's other side and we get a person full of whimsical inconsistencies. Sir Francis' sin was his over-sensuality and the fact that he had the money and position to indulge it. He had adolescent fantasies he never grew out of, which made him adore dressing up. By the time he was forty he had travelled around the Continent, sampling every pleasure it had to offer. When he returned to England to settle down, he was no more mature than when he was twenty.

He had already become an enthusiastic member of a number of exotic clubs, but they did not meet his more lusty requirements. Vague plans of the perfect club, which would provide its members with excitement, blasphemy and women, took shape in his head.

It was in Italy that he conceived the idea of the Hellfire Club. Dashwood's club was not the first or only society for those seeking extra pleasures. It came to him when he attended a service in the Sistine Chapel at the Vatican, during which the worshipers scourged themselves with whips. When told that the chastisement was only simulated, Francis was outraged. He returned to the chapel during a Good Friday service with a horsewhip concealed under his waistcoat. When the lights were dimmed and the flagellation began, Dashwood rushed forward and began to thrash the congregation properly, and one might say painfully. The astonished worshipers fought back and a fight ensued, which resulted in Sir Francis making a hasty exit. While in Italy he suffered the ignominy of being

thrown out of the country for scandalous behaviour. It is said that he tried to seduce a Russian empress while disguised as the king of Sweden.

When he returned to England, he was determined to set up his own club, and in 1753 became friends with Francis Duffield, a young landowner whose ancient home, Medmenham Abbey, was some 6 miles south of West Wycombe. Duffield's home had once been a twelfth-century Cistercian monastery, and despite it having been dissolved for over 200 years, an odour of sanctity still pervaded it. It was here that the 'Knights of St Francis' would meet for two weeks of unalloyed debauchery every summer. There numbers included Lord Sandwich, the 1st Lord of the Admiralty; Thomas Potter, the son of the Archbishop of Canterbury, paymaster general and vice chancellor of Ireland and the Earl of March; and George Bubb Doddington, Baron of Melcombe Regis.

The abbey was well located in a grove of trees, which nearly concealed it from view. The nearest road was some distance away, but members would be able to approach it easily in private boats and could return to their homes in complete privacy. When Dashwood leased the abbey from Duffield, workmen were sent into rebuild the ruins and to landscape the grounds to make a 'garden of lust'. Marble pillars with carved pornographic descriptions were erected. The cave of Trophonius was hollowed from a hill. A fresco depicted sexually robust animal, a crowing cock and a laughing nun. A statue of Priapus was erected in the grounds carrying the motto 'peno tento nonpenitento', 'I feel my penis'. Along the walls were pictures of prostitutes, and it was said that the abbey's library contained one of the most complete collections of pornography in England.

Exactly what Freudian reason lay behind Dashwood's desire to derogate the church is anyone's guess. Whatever it was, it was strong and found no lack of sympathisers. Perhaps all the mock-devil worship was an outlet for ridiculing the church and religion they had all turned against. Then again, a more obvious reason may well be the marital unhappiness of most of the members. For them the club was a relief to get away from home and mingle with woman who were out to please. Dashwood's wife was described as a 'forlorn, Presbyterian prude'. Paul Whitehead had married a rich, but half-witted, ugly heiress. Doddington promised his mistress he would never marry anyone else, giving her a £10,000 bond on his word. When he did marry, he had to keep it a secret for seventeen years until the mistress died and released him from his contract.

By 1763 the club had begun to decay. Doddington and Potter were dead Duffield died at the age of twenty-six, and at least two other members were dying of drink. It was time for Dashwood to call it a day and retire to West Wycombe.

However, his youthful enthusiastic temperament never failed him. With the equally enthusiastic and loyal Paul Whitehead he began to think of ways and means of continuing the club in a different headquarters, where the remaining brothers could meet. He came across the ideal place on his own doorstep. Those who could still attend the club meetings came down from London. Newcomers were introduced and local girls and the capital's prostitutes were recruited to provide the entertainment.

But the old zest was going, try to hide it as they might. There was a hollow ring about the laughter and drunken shouting that echoed around the Wycombe tunnels. Whitehead had become a senile old man, and Dashwood's seemingly fantastic powers and staying

power were beginning to fail him. The meetings of the club gradually and imperceptibly began to fall off. Within six months of each other, Mrs Whitehead and Lady Dashwood died, and their husbands were amazed to find what grief this caused them. In 1774, Paul Whitehead went to his grave, and Sir Francis took a mistress by whom he had a daughter. Gradually, the founder of the Hellfire club retired into respectable domesticity, sitting by the evening fire as his mistress read to him.

Inevitably, Sir Francis became ill. But he refused to give up his lust for life. In December 1781, aged seventy-three and nearing death, he was planning another trip to Italy. He died on the day of his proposed departure.

It has been said of Dashwood that a man may be sinful but still be spiritually aware. With all his faults, he was very much a product of an indulgent age. And if one was going to be an outrageous hellraiser you might as well be, as one historian has said, 'The most likeable and interesting of eighteenth century rakes.'

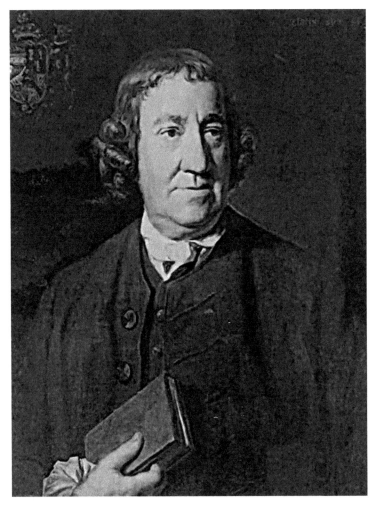

Sir Francis
Dashwood.

## DID YOU KNOW?

In the early 1980s a lady friend of the Dashwood family was visiting West Wycombe Park and asked if she could see the infamous Hellfire Caves. It was winter and the caves were locked for the season. Nonetheless, the sixty-year-old spinster was so keen to see where all the black magic mumbo jumbo had taken place that the tunnels were opened for her. She had been told of the ghosts and phantoms that were said to wander the passageways of the labyrinth, but she dismissed this obvious attempt to dissuade her from entering the caves and brushed it aside with a laugh, adding that she would walk the darkened passages alone, armed only with a torch.

The tunnels were duly opened for her and she entered. She was, indeed, by all accounts, a fiery woman not given to flights of fancy. She had remained unmarried and had always eschewed the company and pleasure of male admirers. In fact, it seemed she was something of a prude who had brought her Victorian code of morals into the modern era. For her, the permissive society was something that happened to other people.

As the lady proceeded into the caves, she soon reached what is known as the banqueting hall – a vast cavern carved out of the chalk and used by the members of the Hellfire Club for their drunken dinners. It was also the place where the members practised their 'devotions' with their female companions, and the alcoves lining the walls of the cave were where much hanky panky and giggling pleasure was indulged.

As the fearless spinster looked about her, she had a most, one might say, life-changing experience. In the shadowy dark, and without warning, she says she had the unmistakable sensation of countless invisible hands touching, caressing and fondling her body in a most amorous and sensual fashion. From head to foot the unseen hands explored her plump, curvy figure, probing in places the good lady had never before been prodded. Terrified, she fled at once, shrieking from the chamber and back to the exit. Never again would she venture into such an evil, immoral and godless place. She kept her promise and never returned to West Wycombe.

However, some years later, it became known to the Dashwoods that following the spinster's frightening, but sensual encounter in the caves, a change had come over her. Whether it was the randy attentions of the ghost of Sir Francis Dashwood, or the drunken lecherous groping of his phantom disciples, we will never know. But totally out of character, the spinster decided to thrust off her prudish shackles regarding Victorian morality and disdain for the pleasures of the flesh, and began to court the friendship and pleasure of male companions. Threescore years of celibacy were abandoned as a dormant sexual awakening burst into life and she became a raving nymphomaniac.

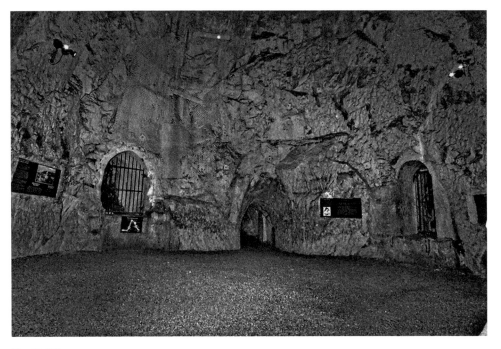

The Hellfire caves.

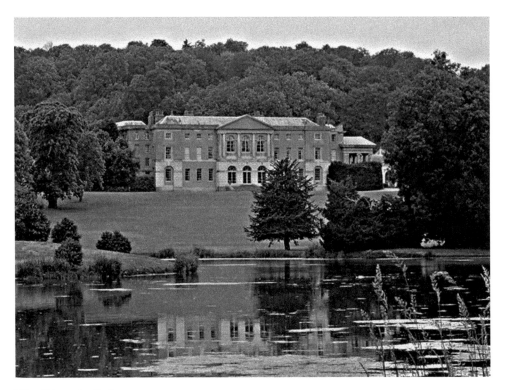

West Wycombe Park.

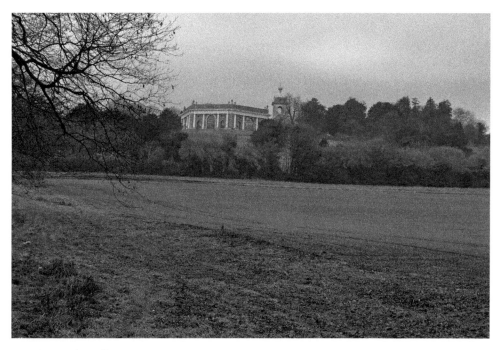

West Wycombe Hill.

## Two Ghost Stories Revisited

In a previous book, I wrote about High Wycombe's haunted heritage and the spooks and phantoms that walk the town and surrounding countryside. Following the publication of *Haunted High Wycombe*, I received a number of letters from readers recounting their own ghostly experiences. Many of these were intriguing and may yet be included in another volume. Two of the letters I received contained information regarding two ghostly encounters that were first included in *Haunted High Wycombe*. Such was the puzzling nature of these experiences, I have decided to include them in this book. Both display the uncanny and unknowable nature of what we might term as the paranormal. Firstly, there is the original encounter, which is followed by the mystifying, and in one of the cases, tragic, postscript.

### The Man in the Road

On an unspecified date in the 1860s/70s, a coach en route from London to Oxford stopped at Beaconsfield to take on a fresh team of horses. It was late, and the driver was eager to make for High Wycombe before dark. The evening was misty and the coach, on leaving the town, was soon lost within the increasing mirk. The road from Beaconsfield to Holtspur, at that time a remote farmstead, is fairly level. Beyond the farmstead the route begins a long gradual descent to Loudwater, which allowed the driver to pick up speed, thundering the fresh horses down White Hill (the present A40). At the foot of the hill, by Wooburn Moor, the road makes a slight dip (adjacent to today's Tesco car park} As the coach came hurtling down into the impenetrable fog, the horses panicked, and the

driver lost control and sight of the road, crashing the vehicle into the icy waters of a local pond. All on board, including the horses, perished. It is said that on the anniversary of the tragedy the cries and screams of the doomed passengers and neighing horses can be heard echoing throughout the area.

Some seventy years later on a misty winter's night in 1936 a lorry was travelling down White Hill towards Wycombe. As it reached Wooburn Moor, a man dressed in a black coat suddenly stepped from the side of the road and into the path of the truck. It was too late to stop and the driver couldn't avoid hitting him. Both the driver and his mate watched in horror as they saw the figure go under the vehicle. Convinced they had struck the man, they hastened from their cab to lend assistance, but when they went to look for the body there was nothing to be found. The road was empty. Even so, the distraught men informed the local police, who also could find no trace of the man. Later, the officer who had attended to the scene informed the shaken driver that other people had reported the same thing happening to them on that stretch of road. Could the apparition of the man in black be the spirit of one of the ill-fated passengers from the doomed coach? Who can say? It would certainly add substance to the story of the fatal crash.

I was to later learn that the two men, although shaken by their experience, carried on their journey, which would have taken some more hours as they were delivering their cargo to the city of Gloucester. They proceeded on the route through Wycombe and out of the town by way of the A40 and onto West Wycombe. They quickly passed through the sleeping village and onward towards Stokenchurch. However, just as they were leaving West Wycombe, their lorry started to experience engine trouble. Coughing, sputtering and losing power, it gradually slowed until it was barely moving. Back in 1936, and at that hour, the prospect of meeting other traffic on the road was remote. However, as the lorry began to crawl to a halt, the driver and his mate looked ahead and were surprised to see the red tail lights of a large stationary vehicle in the middle of the road. Soon they could see the frantic waving of a man with a flashlight who seemed to be signalling for them to stop. The lorry finally coughed its last immediately behind the stationary vehicle and was approached by the waving man.

'Hello pal, the man said, you couldn't give us a hand, I've broken down'

The driver and his mate looked at the dead dashboard of their own vehicle and told the other driver it wasn't their night. They were having trouble as well. Both lorry crews were soon looking under the bonnets of the respective trucks, trying to see what was wrong. Presently, cigarettes were passed around and small talk struck up.

'It's been an odd old journey' said the first truck driver who had waved the flashlight. 'About an hour ago we were just outside Wycombe coming down White Hill and my mate and I could have sworn we hit some chap standing in the middle of the road. Walked right out in front of the lorry. I tried to break but it was too late. Fair shook us up it did. Strange thing is, when we went to see if he was ok, there wasn't a sign of him. He was nowhere to be seen.'

Both driver and mate looked at each other with open mouths and raised brows. The two crews then exchanged experiences and all agreed it was indeed a peculiar coincidence. Soon after, without finding a reason for the engine fault of both trucks, the two lorries ignitions were turned and, much to everyone's surprise, started without trouble. It was indeed turning into an unusual night.

With everything seemingly back to normal, the trucks moved off and carried on their respective journeys. The first lorry that had broken down had only a short distance to travel before it unloaded its cargo and returned to London. Toots were exchanged as the trucks went their separate ways and their red tail lights disappeared into the night. Around an hour later, the crew had delivered their load and were now making the return trip down the A40 between Stokenchurch and West Wycombe. Just before they were to enter the village, they saw up ahead the lights of a vehicle stationary by the side of the road. The lights were flashed indicating they wanted the approaching truck to stop. As the lorry slowed and neared, they could see a man in the road gesticulating for the vehicle to pull over. They drew alongside and heard the man say he had broken down. The driver and his mate looked at each other and shook their heads.

'You just come through Wycombe?' they asked.

'Yeah', came the reply, nearly ran over some chap standing in the road at the bottom of White Hill. When we went to look he wasn't there'.

### The Babes in the Wood

On an October night in 1995, fifty-four-year-old Michael Powel, a keen treasure hunter went to Penn eager to explore the adjacent fields for ancient artefacts such as coins, buttons and broaches dropped and lost over the centuries by long gone residents of the village. Past expeditions at other sites during daylight, however, had seen him flee the wrath of farmers outraged that their crops were being trampled and crushed by hooligan treasure hunters. Consequently, Powell decided to carry out his metal-detecting activities under the cover of darkness. Parking his car in a layby part way along Common Wood Lane, he made his way on foot up through Pugh's Wood and out into the fields near to Puttenham Place Farm, and onto the very path where Sara Osborne had encountered the strange figure of the headless man eight years earlier. On this night Powell would also come into contact with something equally uncanny, and no less disturbing.

Listening for the bleep on his metal detector and keeping an eye out for vigilant landowners, he silently explored the fields, yet after an hour of fruitless searching he decided that there was little, if anything of worth to be unearthed. He decided to pack up and return home. He made his way back into Pugh's Wood and down to his car. He had only gone so far into the trees when he heard voices. He stopped and listened intently, and realised that they were the laughs and shouts of children. But he was puzzled: what were children doing in a wood at that hour? As he continued to listen, the voices seemed to becoming closer. It struck him that, even though it was 3 a.m., the children had to be accompanied by an adult, and if he were discovered he would be in the embarrassing situation of explaining his own presence at that hour. He remained still and continued to listen. He was relieved to hear the voices of the children heading away from him. Yet, just as he thought they had moved off to the far side of the wood, he once again heard them, but this time they were from his rear. He quickly spun around. The laughter and singing of the children was coming from behind him, and rapidly heading in his direction, but there was no sound of the snapping of twigs or the rustle of bushes, only the playful yelps and shouts of two youngsters. As the sounds came closer, Powell expected the children to appear, but there was nothing to be seen in the darkness of the wood. Just as quickly as

the voices had sounded behind him they immediately changed course and now emanated from the direction of the fields, seemingly fading and then sounding close again. Powell swung left, right and behind wondering what was happening. The sound of the children seemed to be all around him. It was at this point that he became scared and immediately realised that what he was hearing was abnormal. Hurriedly, he moved down through the wood and back to his car. He got in and, before starting the engine, wound the window down and listened. There were no sounds coming from the wood, only the wind in the trees. He quickly drove away shaking his head, his eyes on the illuminated road, expecting at any moment to see two ghostly children walk out in front of him.

Michael Powell, who died in 2005, was a friend of the author of this book, and the above encounter was related over a pint in a Wycombe pub not long after the episode. Powell knew of my interest in ghosts and, convinced he had indeed heard the spirits of two children, asked if I could throw any light onto his experience. At the time I couldn't. It appeared to be a one off incident, and one I had never before come across. If the phantom children had been experienced by others, they had kept their silence. Powell never returned to the wood either by day or night, but for many years was intrigued and baffled by what he had heard that night. The detectorist, in his search for ancient relics, had explored many locations during the small hours and often in places many of us would hesitate to venture after dark. But Powell took this all in his stride, and was not a person to become easily spooked by being alone in a field or wood at night. Yet his experience in Pugh's Wood had been the only time in his detecting career when he felt truly frightened.

The puzzle of the phantom children would have remained a mystery had it not been for a chance browse on the internet some years later, revealing a distressing yet intriguing coda to the story. On 19 November 1941, six-year-old Kathleen Trendle and Doreen Hearne, aged eight, were on their way home from Tylers Green School in Penn. They had reached the crossroads by Elm Road and Common Wood Lane, which runs alongside Pughs Wood, when an army truck pulled up beside them. The driver leaned out of his cab and offered the two girls a ride. Both got in, and the truck drove off in the direction of the village of Penn Street. The children did not return home that night, and three days later their bodies were discovered in a nearby wood. Both had been strangled and stabbed.

Close by were the tyre tracks of a lorry and a large patch of oil. There was also Doreen's gas-mask holder and a khaki handkerchief with the laundry mark RA1019. A twelve-year-old boy had told police that he saw the two girls getting into the truck, and gave the unit identification marks of the lorry. The vehicle was quickly traced to a unit, 341 Battery, 86 Field Regiment, Royal Artillery, in Yoxford, Suffolk, and they soon came across the truck with a leaking back axle. The tyre tracks matched the impressions taken from the scene. The driver was twenty-six-year-old gunner Harold Hill. He had the laundry mark RA1019 and his fingerprints were found to match those on the discarded gas-mask container. When his kit was examined, his spare uniform was found to have bloodstains on it. His plea of insanity was rejected and he was hanged at Oxford Castle on 1 May 1942.

As we have seen, such dreadful and disturbing events can sometimes leave a trace. Not long after the publication of *Haunted High Wycombe*, I received a letter from a Mr Tom

Reece and his friend Max Hadley. One night after a family party they were travelling home by car from Wycome to Amersham. They had decided to go across county rather than take the main road out of Wycombe. It was past 2 a.m. when they were driving along Common Wood Lane towards the village of Penn Street, which their route would take them through on the way to Amersham.

The road was dark and deserted but with occasional mist patches lingering in the hollows and fields. As they rounded a bend in the road, the full beam headlights of the car picked out a strange vision. Standing by the side of the road, on the opposite carriage way, were the unmistakable figures of two children. Mr Recce, who was driving, did not, at first, think it strange. However, as the car neared the children, his friend Mr Hadley sat stiffly up in his seat and exclaimed in an incredulous tone, 'What the hell?' Both men then fixed their eyes on the odd sight as they approached. Mr Reece says they were travelling at around 35 to 40 miles per hour, and it must have taken around seven seconds for them to first see the kids, register them and then quickly pass. As they did so, they saw that the children had their backs to the road and were staring across the field up to a wooded area.

'It all seemed to happen in a flash' Mr Reece reported. 'I was tired and wasn't thinking about anything in particular when I saw the figures. Max sat up and shouted. We both briefly glimpsed at the children as we shot pass. They looked completely solid and normal. If it wasn't for the lateness of the hour I wouldn't have thought it odd.'

However, Mr Hadley was of another opinion. When his friend said 'should we stop and see if they are ok?' the reply was a firm 'no'. 'Just drive, just drive.' Max instinctively knew that what they had seen was not right, not normal. He says a cold shiver coursed through him as they passed the children. All he wanted to do was to get the hell out of there. As the car continued on down the lane, Mr Reece checked his rear-view mirror, but it was impossible to see anything save the dull red glow from his tail lights.

When they returned home to Amersham, both found it hard to sleep. While Max tried to reason the vision from his mind, Tom Reece was of the opinion that they had seen the ghosts of two children. This uncomfortable realisation seemed to be confirmed when they read the account in *Haunted High Wycombe*.

What is tragic about the murder of two innocent children is that it might never had occurred but for a cruel twist of fate. On the day the girls were abducted, they left Tylers Green School at the normal time of 3.45 p.m. and, along with other pupils and accompanying parents, proceeded homeward. They were some distance from the school when one of the girls, realising she had forgotten something, asked her friend to return to the school to fetch it. Both went back to the classroom, but after twenty minutes of fruitless searching gave up and once again left the building. By now, the other children and parents had dispersed and the two girls walked on alone. When they reached the crossroads at Common Wood Lane, they had their fateful meeting with their abductor.

If this dreadful incident was an instance of pre-ordained synchronicity, then it was a cruel, heartless and devastating example, and one that was meaningless. Likewise, what are we to make of three truck crews encountering the same road apparition and then all

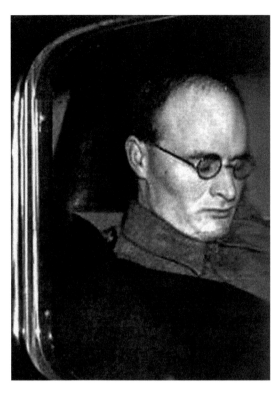

*Left*: Harold Hill. He abducted and murdered two Tylers Green children in 1942.

*Below*: The junction at New Road and Common Wood Lane where Hill took the children.

experiencing engine trouble at the same spot? All are uncanny incidents. One will bring tears to your eyes; the other makes you scratch your head and search for an answer.

When the great Edwardian ghost story writer and academic M. R. James was asked did he believe in the supernatural he replied, 'Yes', but added, 'We do not know the rules.'

## The Man Who Saw His Own Funeral

One of the more puzzling aspects of the paranormal is the phenomenon known as 'crisis ghosts', or 'phantoms of the living'. Curiously, in the archives of the Society for Psychical Research there are just as many accounts of apparitions of living people as there are of those who have passed on.

Many accounts of a crisis ghost have taken place during wartime. A family or friend of a person who is known to be overseas serving in the army are one day surprised to look from the living room window and see Uncle Fred or Aunty Freda walking up the garden path towards the front door. Soon after there is a knock at the door, but when opened there is no one there. What the family doesn't know is that at the time of them seeing the relative or friend, he or she was at the moment of death on some far away battlefield. And perhaps their last dying thought was of home or else someone they needed to help them. One such occurrence of a crisis apparition took place in Wycombe in the eighteenth century.

William Shelbourne was the youthful heir to the Bowood family estates in Wiltshire and was said to have seen his own funeral in a dream. The young man saw himself unwell in bed while preparations for a journey were being planned around him. As he looked on, servants came and lifted him and carried him prone to a waiting carriage that was to join a procession line of vehicles. When he tried to ask what was happening, he found he had couldn't speak.

Shelbourn was placed laying down in his carriage and the procession moved off. After some time it stopped by the gates to All Saints Church and, as the young man was lifted up and carried along the path to the church doors, he noticed that he had been taken from a hearse and that everyone was weeping and dressed in black.

Thankfully, he woke up in the morning, freeing him from his distressing dream. Nonetheless so disturbing was the experience that William immediately summoned Dr Priestly, the family physician, to tell him about it. Shelbourn was convinced that it meant some ill fortune was to befall him. The doctor found him in a disquieting state of nerves and tried to reassure him as best he could. As the weather was bitterly cold, Priestly advised the young man to stay by his fire and try to forget the night's events.

However, the doctor could see in Williams's demeanour the soul of a troubled man, and was sufficiently concerned to pay the youth a return visit on the following day. As the physician approached the house he was surprised to see William running towards him, particularly as there had been a fall of snow and the ground was slippery underfoot. Before he reached him, the youth suddenly seemed to vanish. Such was the doctor's surprise that at first he assumed Shelbourn had gone behind a hedge and hidden, fearing a rebuke for disobeying him. Some moments later the doctor entered the house and was shocked to be told that William had died in his room just minutes earlier.

Several days later a mourning cortege of carriages followed behind a hearse to the gates of All Saints Church, just as Williams dream had foretold.

## The Hughenden Dragon

One of the fascinating aspects of a towns secret history is how time after time myth and partial fact, together with a host of Chinese whispers, are interwoven to become an unsubstantiated belief. A story so preciously traditional it cannot be dismissed or put under the spotlight of logic or reason. A tale, even though seemingly preposterous, we want to be true. One such story was related to me during the research for this book.

It was while I was relaxing with a pint in a local that the barman, knowing of my research into High Wycombe's secrets, asked if I had ever heard of the Hughenden Dragon. No, I had not, but I insisted he relate the story. As is the norm in such a retelling, the barman could only offer me what scanty details he had heard, and those were probably picked up from someone who himself had been told of the tale from a third-hand party. Nonetheless, the story was so intriguing I asked him to tell me all he knew.

Back in the 1920s a mother and her baby were walking in Hughenden Park. The baby was in a pram, and as they neared an ornamental pond or lake, a creature rose from the water and tried to attack the mother. She managed to fight it off, yet the thing persisted in its attack and made to lunge at the baby's pram. The barman was not sure what happened next. Either the mother managed to escape or, some say, the baby was swallowed up by a dragon from the pond.

It is a fantastic tale and, sadly, totally preposterous. Such an incident would have had the authorities descend on Hughenden with all manner of weaponry to catch or kill Wycombe's answer to the Loch Ness monster. However, as is often the case, there might well be a hint of truth in the story. Even the most outlandish folktale has a morsel of fact at its root. For that we must go back to the mid-eighteenth century.

In October 1758 a letter appeared in *The Gentleman's Magazine* from an Edgar Bochart relating the story of a water serpent he had come across while travelling through Wycombe during the summer. Bochart thought the story ridiculous at first but had sufficient curiosity to seek out a farm, which locals was supposed to have the incident depicted on a wall. He went to the farm and found, on one of its walls, a painting of a dragon-like creature and a pencilled record of its history. The story, which he felt 'in every respect, to be true', is as follows:

A woman of the farm was used to getting water from a nearby pond. In the year 1578, she was troubled by a large water serpent, which she frequently saw when she went to get water. The woman was frightened of the creature and told her neighbours about it. A plan was then agreed to do away with the serpent. The woman was to attract the beast by sitting by the pond side, while some of her neighbours hid behind the briars, which almost surrounded the water, ready to kill the creature. The plan was successful. To mark the event, the serpent was stuffed with straw and hung up outside the house. Over the years the skin rotted and so a likeness of the creature was painted on a wall of the farm. The painting also gradually deteriorated and so had to be restored from time to time. The likeness Bochart saw showed a creature that looked like a traditional dragon.

Hughenden Park. Supposedly the haunt of a dragon.

The house that contained the dragon painting was described as having: 'Coats of arms visible in many places' and inferred that it must have been a hospital of the Knights Templar. He also stated that around half a mile into the valley beneath the house was the Church of Hitchendon in the Buckinghamshire, which housed memorials to some of the knights. Hitchendon was the seventeenth- and eighteenth-century name for what is now the parish of Hughenden. What Bochart was referring to was the Church of St Michael and All Angels, Hughenden. The dedication is particularly interesting in that St Michael's churches are frequently associated with dragon legends.

In the eighteenth century, around half a mile from the church, stood the ancient manor house of Rockhalls. In previous centuries this had been the home of the Wellesbourne family, who are known to have had a penchant for armorial carvings, to such an extent that during the reign of Henry VIII some of the Wellesbournes claimed, without any grounds, to be descended from the family of Simon de Montfort, the French nobleman who organised the first English Parliament. They even went to the trouble of having fake

monuments, supposedly if de Montfort/Wellsborne ancestors made and placed in the chancel aisle at Hughenden Church.

Sometime towards the end of the eighteenth century, the old Rockhalls were pulled down, but a number of carvings were saved and incorporated in the buildings now known as Rockhalls Farm and Brands Lodge, where they can still be seen today. The armorial carvings identify Rockhalls as the house where Bochart saw the dragon painting. However, it is harder to identify with any certainty the pond in which the dragon was supposed to have lived. One believed site is on the opposite side of the road from Rockhalls Farm, about 100 yards up the road towards Widmer End. However, this pond may only be what remains of the old Rockhalls moat and tends to dry up in the summer. Today, it has silted up and is surrounded by bushes and brambles, which are very easy to imagine as Bochart's 'briers'.

Now, of course, Rockhalls Farm is situated some way from Hughenden Park, and if the mother with her baby in the pram was attacked by a creature in the moat then it would now be a well-known piece of local folklore. But this does not seem to be the case. One nineteenth-century historian referred to the Hughenden dragon as 'one of those absurd stories which have a tendency to retard the human mind in its progress to a rational improvement, and which are therefore to be discountenanced by every friend of historical truth'.

Nonetheless, although the dragon story was dismissed as a fairy tale by many, there are some local people who can recall a particular pond in the vicinity of old Rockhalls, which certainly held a fear for anyone passing by it. When the story of the dragon first appeared in a local paper, it prompted correspondence from an elderly lady who had heard the tale of the serpent when she was a child. Her father had told her of a woman and baby being swallowed up by a dragon from a pond located somewhere between Terries and Four Ashes. The pond was said to be reached by a footpath off the Kingshill Road, and reputed to have been where Simon de Montfort had his castle. Although there is no evidence pointing to de Montfort's castle, today there is still a small moat and a deep ditch said to date from around the twelfth century – the same date as when Hughenden Church was built. As a child the lady was always afraid when she passed the pond and the thought that a hideous water serpent would rise up and take her.

The pond indicated by the lady would appear to have been the same as the one referred to by Bochart. Undoubtedly, local tradition, and the gloomy nature of the pond and its overgrown surrounding, had distorted the story into one of a woman and baby being swallowed by the beast. It is a suitably spooky and romantic tale for retelling around the winter fire, and even the most hardened sceptic would surely want it to be true. However, we may not be referring here to a real dragon or serpent but a symbolic one.

Over the centuries many religious sites have been used continuously. What was an initially pagan site would in turn become Christian, and eventually a parish church would be constructed there. A network of ley lines are said to connect these sites. These lines across the landscape became associated with the ways of the dead. At certain times of the year strange lights and phantom creatures were seen, and where the paths intersected it was believed that supernatural phenomenon was heightened.

Whatever ones views on ley lines are, it has been shown that an unusually high number of paranormal incidents have been recorded where they have been mapped. Moreover, these lines were also known as 'Dragon Paths'. The idea and force of the dragon or serpent was intrinsically connected to the scared and supernatural power of the site. Such an ancient British link would have no doubt lasted down the centuries until the Anglo-Saxons arrived in the country.

The Anglo-Saxons were initially pagans, yet, in the year 597, Pope Gregory sent St Augustine to England to convert the bloodthirsty heathens to Christianity. Included in his remit was to replace those old heretical beliefs with Christian teaching as a sign that the old ways were being superseded by a far more powerful doctrine. The emergence of Christianity also included symbolic subservience and a replacing of pagan icons with Christian ones.

When the first Christian place of worship was established at Hughenden, it is possible the builders might well have been aware of the areas heathen past and its dragon path associations. Therefore, what better person to dedicate the building to than the biblical slayer of dragons, St Michael. Such a dedication would have signified that Christianity had triumphed over paganism and their supernatural beliefs.

The power of time and the centuries, together with the passing down of folklore, to distort and add to ancient tales is common all over Britain. The account of the Hughenden Dragon, and its slaying by the locals, which Edgar Bochart came across 200 years ago and dated back even further, may well be the ever-changing narrative of a tradition whose origins are now so remote as to be lost forever.

# 3. Wycombe Fun and Games

## Parachutes over Wycombe

On an August bank holiday in 1891 all of High Wycombe was in a state of high excitement when it was announced that the daredevil Professor Higgins, accompanied by his lovely assistant Miss De Voy, the renowned parachutists, were to ascend in a gas balloon to an astonishing height above the town, whereupon they would leap off and descend safely back to earth by parachute. The professor was an old hand at this exceptional feat of daring. He once parachuted from a balloon 12,000 feet above Wolverhampton and survived.

The Wycombe take off and jump was scheduled for 6 p.m. from Loakes Meadow and vast crowds had gathered to watch the two intrepid flyers ascend. But all didn't go according to plan: the balloon, once filled with gas, went sideways instead of going skywards, scattering the crowd as it scraped and brushed along the floor. Miss De Voy, sensing that she would get no higher than the treetops, leapt from the balloon as it climbed pathetically upwards, before passing over the western end of town and coming down to earth coughing, spluttering and deflated in a field.

Who was to blame for the balloons dismal performance? Parachutists accused the gas company of filing the balloon with inferior gas. The gas company accused the flyers of having a second-rate craft that let the gas seep out as almost 70,000 cubic feet of good quality gas had been pumped into the balloon. All were disappointed, especially the Wycombe crowd, who with great restraint refrained from showing the failed jumpers what they thought of them. A week later the Professor and Miss De Voy were offered the chance to redeem themselves, with the incentive of £30 if they completed the jump. However, only a few days before at Paignton in Devon, another parachutist professor was almost lynched when his planned jump failed to get off the ground. Similarly, in Nottingham 5,000 spectators, having been kept waiting for over two hours, went berserk when another parachute jump failed to happen. They tore up the balloon and mobbed the police station where the terrified parachutists were hiding.

Bearing this in mind, the Professor and Miss De Voy thought better of risking their lives to a baying mob if things didn't go according to plan and, with their faulty balloon, quietly slipped away from Wycombe.

What was to be done? The crowd still wanted to see someone leap from a balloon over the town. Up stepped nineteen-year-old Cissi Kent, pretty as a picture and without an
c      f fear. The ascent was planned to take off from the Wycombe gasworks. A vast
          d gathered including the mayor and council dignitaries. Members of the fire
          'd the balloon, and were on standby in case a stray cigar ember found its way
          d gave Wycombe its own version of the Hindenburg Disaster. Miss Kent
          n clad in a blue velvet knickerbockers suit, cap and light-pink stockings,
          after a dinner of soup, lamb cutlets, plumb pudding and a bottle of

claret, the cheering crowds watched as she lifted off into air. A slight breeze got up and carried Miss Kent along the Wycombe Valley, where her balloon rose to the astonishing height of 6,000 feet. Soon, the white mushroom of her parachute could be seen drifting slowly down to earth where it landed safely in a barley field near the Rifle Butts pub. There were cheers all round and everyone concerned repaired to the Red Lion Inn where they stayed for the rest of the evening. The balloon made its way to Surrey where it crash landed in a cornfield.

## How Not to Treat Our Furry Friends

One of the great progresses of modern times is, of course, our attitude towards and treatment of animals. I can remember, some years back, watching an episode of *Time Team* where archaeologists were investigating a hillside in Oxfordshire. Before they were given permission to let fly with their shovels and picks, they were required to ensure that no wildlife, in particular the humble field mouse, which had made the hill their habitat, were harmed. Even today, any new major road scheme has to have tunnels created below the carriageway to allow animals, such as badgers, to pass without the need to dodge a hurtling 24-tonne, articulated lorry. Such enlightened attitudes would have seemed laughably absurd to our Victorian forebears. Even in nineteenth-century Wycombe the notion of regarding animals as creatures worthy of respect, and not purely beasts of burden or objects for entertainment, would have seemed incomprehensible.

On most Saturday mornings many of us have travelled into the centre of Wycombe, perhaps to do a little shopping, meet with friends or have a coffee and take in what street entertainment there is on show. This would normally be nothing more alarming than a busker wailing his songs to no one, a market trader shouting his wares to prospective buyers, or someone trying to sell us magazines we will never read. However, go back to nineteenth-century Wycombe and the entertainment on display would have us staring goggle-eyed, with a hand clapped to our mouth, in horrified disbelief.

In 1883 one of Wycombe's chief amusements was the barbaric practise of bull-baiting. On Saturday mornings, outside the Falcon public house, a poor unfortunate bull was led into a cordoned-off ring and fastened with ropes. Bulldog owners in the crowd would then pay a shilling to have his dog attack the bull. If the dog was successful in pinning the animal, the owner received a crown.

Occasionally, two owners would back their dogs against each other for a wager; the one who pinned the bull most times out of a certain number of attempts previously agreed upon was declared the winner. Sometimes disputes arose between the two dog owners as to who had won the baiting. This often resulted in the ridiculous spectacle of the bull, the bulldogs, and no doubt the cheering crown, looking on as the two men beat seven shades of manure out of each other to settle the score.

Sometimes the bull got the better of the dog. Before the beast could move in for the kill, the owner would rush forward and try to save his pet. This would give the bull the opportunity to have a go at the dog owner and toss him in the air much to the uncontrolled hilarity of the crowd. Occasionally the bull got the best of the dog and gorged it to death.

Sadly, however, most of the time it was the poor bull that came off worse. The dogs would soon exhaust the beast until it had no more energy to resist. Incredibly, as if the whole barbaric scene could not get any more appalling, various devices were used to rouse the bull from his desperate lethargy and to reawaken his anger. He was pricked, poked, kicked and pushed. Unbelievably, if he still chose to remain indifferent, he was set on fire.

Bull-baiting wasn't the only medieval entertainment in nineteenth-century Wycombe. Cock throwing was immensely popular at the time. The pastime was not, as one might think from the title, to throw a cockerel into the air or to see how far one could fling it, but rather to place the poor bird on a spot, tie one of his legs to a stick, retire 22 yards and then throw stones at it. The contestants got three attempts at trying to knock the bird over. The object was to hit the cockerel and knock it senseless. If the thrower could run the 22 yards and catch the bird before he regained consciousness, he won the cockerel.

If it wasn't bulls or cockerels being tortured, then it was the poor, unfortunate badger. Badger-baiting was often held on the Rye. It was just as dreadful an entertainment. The badger was placed under a tub or wheelbarrow; the object of the 'game' was to send in the dog to try and draw the badger out. The dog who could do so won a prize for its master. Not all dogs were successful, and the wily, tough badger would often pull the dog into the tub.

One day in 1883, a passer-by walking on the Rye went to see the horrid spectacle. With him was his dog, a dismal looking mongrel, which at once became the subject of ridicule and laughter from the gathered badger torturers. The passer-by immediately took

The Falcon pub in the centre of town where bull-baiting took place.

umbrage, and offered to bet £1 that his dog, pathetic though he looked, could easily draw out the badger. Up went the hoots and guffaws as the assembled laid their money down, confident of a quick return.

As the doubters looked on expecting the mongrel to go head first into the tub, the passer-by grabbed his pet by the head and thrust his hind quarters into the barrel, where the badger caught him by the tail and held on like grim death. The poor dog, yelping and terrified and obviously in need to be somewhere else, leapt from the tub with the badger's jaws still attached to his behind. It was unorthodox and cruel, but the dog had drawn the badger out, and the passer-by claimed his winnings.

## DID YOU KNOW?

Astonishingly, between 1750 and 1915, High Wycombe and its surrounding areas could boast, at one time or another, no less than 150 public houses. Even as late as 1875 there still remained sixty-two in a town that was much smaller than today. Furniture making must have been thirsty work indeed.

## DID YOU KNOW?

Wycombe certainly lives up to its name. If you stand in the middle of the high street, you are as high as the dome of St Paul's Cathedral in London, 365 feet high.

## When the Movies came to Wycombe

During the 1950s and '60s Wycombe was the chosen location for a number of British film productions. It is perhaps not surprising seeing as the town sits in an area sometimes referred to as the British Hollywood. Before they closed, Beaconsfield and Denham studios, only a few miles from Wycombe, produced many films that still pass the test of time. In nearby Hertfordshire, Elstree studios have been responsible for such blockbusters as the Indiana Jones series and the Star Wars movies. Even closer to home, Pinewood is the home of James Bond, and the Carry On series.

Of course, apart from the pleasure of the plot and story of the film itself, these Wycombe based movies give us a fascinating look at the town from over sixty years ago. In 1958, the Norman Wisdom film *The Square Peg* included a scene that was shot at Wooburn Green railway station. It is a pretty brief segment, but shows part of the branch line that ran from Wycombe to Maidenhead. The location today has completely changed, and, but for a thoroughfare called Railway Place, it would be hard to imagine a train station having ever existed there.

Norman Wisdom returned to Wycombe in 1966 with another comedy film, *The Early Bird*, a tale of an oppressed milkman trying to fight off a larger dairy supplier's attempt to steal his round. A great deal of the action was filmed on Queens Road, Rectory Avenue, and Peterborough Avenue, just off Toterridge Lane near to Wycombe railway station. The storyline required a very steep road for Wisdom to lose control of a fully-laden milk churn, which rolls down the incline and floods a house. Queens Road, being precipitously sheer, was perfect for the stunt.

The action then moves up the hill to Rectory Avenue where the hapless Norman has to chase his two-wheeled milk float down the road. The film then cuts to Peterborough Avenue, and then, as mostly happens in the movies, cuts once again to a location miles from the original scene. In this instance a road in Iver, near Slough.

Other movies that have been filmed in or near the town include the *Those Magnificent Men in their Flying Machines* (1965), part of which was shot at Wycombe Air Park in Booker; *The Dirty Dozen* (1967), partly shot at Bradenham Manor; *To the Devil a Daughter* (1973), which climaxes on top of West Wycombe Hill; and the relatively recent 2003 Rowan Atkinson film *Johnny English*, which was shot in Hughenden Park.

One movie, which is perhaps the best for showing the town some thirty-five years back, is the British production *Revenge*, staring Joan Collins and Anthony Booth. The plot concerns the murder of a child. Both the police and grieving family have a prime suspect, but they lack firm evidence to convict him. Consequently, the parents of the child decide to exact their own revenge, with devastating consequences for all concerned.

The film opens with a scene shot at Little Marlow Church, and then continues onto a public house on the road between Marlow and Bourne End. Further scenes were shot in Bourne End, but the majority of the important action was shot in Wycombe near to the station and included locations such as Gordon Road, Birdcage Walk, Saffron Road, the Rye, and London Road opposite the pub. Railway enthusiasts will be pleased to see that in 1971 Wycombe Station still used semaphore signalling. Also interesting is the changes that have taken place on Gordon Road. Where now there is an elderly person's housing complex, and on the adjacent side of the road, a car park for train travellers, thirty-five years ago the Victorian terraces still stood.

## DID YOU KNOW?

On the 23 August 1969, British super group The Who played at the now legendary festival of music and art Woodstock in upstate New York. They were paid $25,000 for their performance. Four years earlier, on 13 June 1965, The Who played at Wycombe Town Hall, for which they received £100. Two years prior to their performance, the Rolling Stones played at the town hall and were paid even less. Pink Floyd played at Wycombe Town Hall on 23 May 1967.

## DID YOU KNOW?

At one time Wycombe had its own renowned rock and blues music Mecca. Throughout the 1960s, '70s and '80s one didn't need to travel to London to see and hear the latest bands because they came to play at the Nag's Head pub on London Road. Sadly, today, the old 'blues loft' no longer rattles and hums to the beat and throb of popular music, yet in its heyday artists such as John Lee Hooker, Howlin' Wolf, Freddie King, Muddy Waters, Alexis Korner, Jethro Tull, Mott the Hoople, Status Quo, Thin Lizzy, Hawkwind, Long John Baldry, Eddie and the Hot Rods, Dr Feelgood, and Van Der Graaf Generator all played at the 'Nag's'. In 1977 the notorious Sex Pistols took to the stage – happily Wycombe survived.

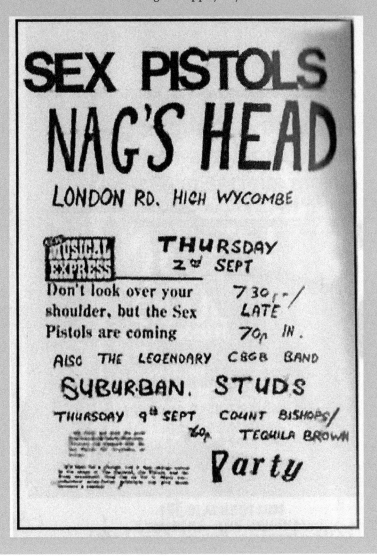

## When Buffalo Bill Rode into Town

If we were asked to name three cowboys from the America's Wild West, one would be Billy the Kid, the second Jesse James, and the third, undoubtedly, Buffalo Bill.

William Frederick 'Buffalo Bill' Cody was born on 26 February 1846 in La Claire, Iowa. He acquired the name 'Buffalo' after it was said he shot almost 5,000 Bison in an eighteen-month period. At the age of eleven, following his father's death, he was required to work for his upkeep. At the age of fourteen, he became a rider for the Pony Express. In 1863, just seventeen, he enlisted in the Union army during the American Civil War. Later, he served as a civilian scout during the Indian Wars, and in 1872 he received the US army's highest decoration, the Medal of Honor.

In 1883 he founded Buffalo Bills Wild West show, which toured the United States. Four years later, the show came to Britain. Incredibly, in 1887 the show played 300 performances in England and was watched by more than 2.5 million people.

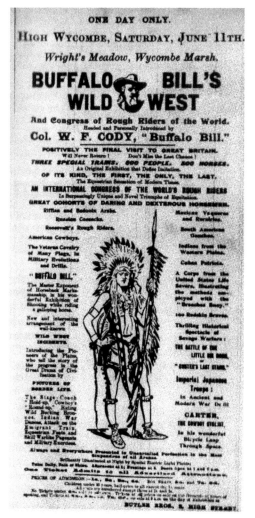

A Buffalo Bill poster.

In 1904 the show made its last tour of Britain, and included on the schedule was a performance in Wycombe. On Saturday 11 June a massive crowd gathered at Wycombe station to greet Bill, Annie Oakley and the mammoth show, which included hundreds of performers, 500 hundred horses, and trainload after trainload of cowboy and Wild West paraphernalia.

The venue for the show was Wrights Meadow in Wycombe Marsh, and it was here that 20,000 people gathered in the afternoon to pay either 1s (5p), or 7s 6d ( 37p) if you really wanted to get a close-up view of the action. You could watch demonstrations of horse riding, lasso twirling, cannon firing, an 'Injun' attack on, not only a lone prairie train (the Deadwood stage coach), but also a settlers cabin, which were all, of course, repulsed by the cowboys. Next came the most daring stunt of all, a man on a bicycle leaping across a 56-foot chasm. The shows climax was a re-enactment of the Battle of the Little Big Horn, where Cody, playing the part of General Custer, was massacred along with 300 of his men by Sitting Bull and the Sioux. Such was the bloodthirsty enthusiasm the Red Skins displayed during the re-enactment of the slaughter that the crowd, so one local paper reported, was left in no doubt of an 'exact conception of the actual occurrence of savage warfare'. All that was missing was the blood and the scalps. The whole show was such a success it was repeated on Sunday where again it drew thousands of spectators, who were no less intrigued or amused to see the 'Red Injuns' bathing in the river.

# 4. Bloody Wycombe

## The English Civil War and the Battle of Wycombe

The English Civil War cost a large number of British lives. It was a conflict that pitted fathers, sons, brothers, cousins and friends against each other. It would devastate the country, destroy towns, villages and homes; see an anointed monarch put on trial and executed; and for the first and only time in her history turn England into a republic. The cost of all this devastation was the loss of almost 300,000 people. This was at a time when the total population of the UK was estimated at only 5 million.

During the war Wycombe sided with the Roundheads and became a Parliamentarian garrison. Its strategic position halfway between London and the Royalist capital at Oxford made it a coveted prize for the Cavaliers. None more so than for Charles I's nephew, Prince Rupert of the Rhine who, early in the war, assaulted the town. He had received information that a wages convoy making for Aylesbury to pay the Roundhead troops garrisoned there would be coming through Wycombe. Rupert decided to attack it and seize the money. However, the townsfolk, having got wind of the prince's intentions, alerted the convoy, which quickly headed for the surrounding woods for concealment. Having not found the wages convoy, the raging Rupert ordered his men to burn and loot some of the town's houses before sullenly making their way back to Oxford.

In December 1643, a more determined effort by the king's soldiers to take the town was launched. A Royalist army of some 4,000 men marched from Oxford towards Wycombe. Instead of advancing from the west, the Cavaliers made a circuitous march north of the town by way of Hazelmere, Tylers Green, down Hammersly Lane, and onto the Rye by way of Back Lane and Bassetbury.

The townsfolk were not slow in responding to the assault, and barricades were set up in Horsenden Lane (now Queen Victoria Road). The Parliamentarian commander of Wycombe Captain Haynes, managed to muster some 4,000 pikemen to repel the Royalists. They advanced across the Rye and fierce fighting commenced. During four hours of battle some 900 Cavaliers and 300 Parliamentarians were killed. The king's army was eventually pushed back onto the Rye, and their commander, Lord Wentworth, being wounded, fled the field.

The fighting continued as the Royalists retreated back across the hills north of the town towards Hazlemere, where it is believed a last ditch skirmish was fought on what is now the golf club. The fighting had been bloody, but Wycombe was prevented from falling into Royalist hands.

The war would drag on for another five years until the Roundheads eventually triumphed. In 1647 King Charles was captured and held prisoner by Parliament's New

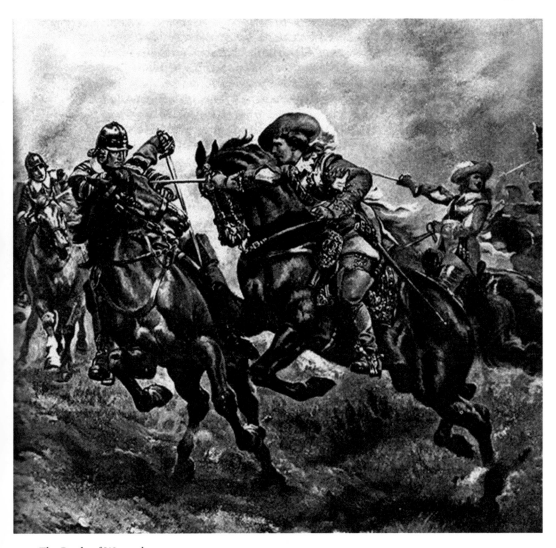

The Battle of Wycombe.

Model Army. During a journey from Caversham to Wooburn in Bedfordshire he passed through Wycombe. Two years later he was tried, found guilty of treason against the nation and beheaded in London. For the next eleven years the office of king was abolished and England became a republic.

In 1660 the monarchy was restored with the coronation of the Charles II. The new sovereign quickly sought revenge on those who had caused his father's death and signed their death warrants. Even those regicides who had died were exhumed and their corpses hung at Tyburn in London. One of king's accusers who was still alive at the restoration was Thomas Scott. He was elected as MP for Wycombe in 1654. Scott was one of the prime movers for the creation of a republic in England, and was also the

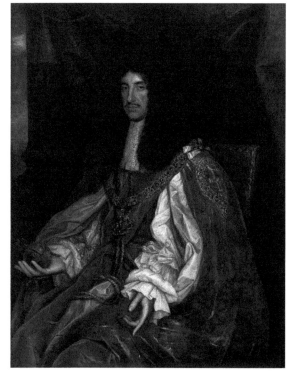

*Above*: WHSmith on the high street. The site of the Katherine Wheel Inn. Charles II spent the night here on his way to London.

*Left*: The merry monarch Charles II.

## DID YOU KNOW?

In 1153 Wycombe was the scene of a bloody castle siege during the civil war between the forces of Stephen of Blois and his cousin Empress Matilda. Stephen was the grandson of William the Conqueror. However, his cousin Matilda was the daughter of Henry I. When he died in 1135, it was thought that she would become queen, but many nobles preferred a male monarch and chose Stephen as king. Matilda would have none of it so civil war broke out. Such was the savagery of the conflict that chroniclers of the day said that: 'God and his Saints Slept.'

Stephen laid siege to the motte-and-bailey structure, which can still be seen in the grounds of Castle Hill House on Priory Road. We do not know the outcome of the siege, but Stephen did prevail in the war and became king of England in 1148, but only on the understanding that Matilda's son Henry would succeed him. Stephen died in 1154 and was succeeded by Henry II.

main organiser of the execution Charles I. Such was his fanatical hatred of kingship that he wanted his tombstone to be inscribed: 'Here lies Thomas Scott, who judged the late King to die'.

At the restoration he fled to Brussels, but was captured and brought back to England where he was tried and found guilty of regicide. On 17 October 1660 he was hung, drawn and quartered in London. Before his execution he was given the chance to recant his crimes, but refused.

Although Wycombe had been staunchly Parliamentarian throughout the war, when Charles II was restored to the throne in 1660, the town changed its allegiance to the crown. This show of, one might say, 'expedient political goodwill' was demonstrated on the day the new king and his queen Catherine of Braganza, together with Prince Rupert of the Rhine, stayed the night in Wycombe during their journey from Oxford to London. No doubt the crowds cheered and waved as the royal party put up at the Katherine Wheel Inn on the high street. Today, the site is occupied by WHSmith.

Many years later Wycombe was to confirm its allegiance to the crown when in 1799, under the patronage of the Duke of York, the Royal Military Academy was founded in the town at the Antelope Inn just across from the Katherine Wheel. It had a junior department based at Marlow. In 1813 the academy moved from Wycombe to Farnham. However, the Marlow branch would eventually move to Sandhurst in Surrey Today, it remains the home of the British armies officer class.

## The High Wycombe Suffragette Riots

The view of violent political protest is one we normally associate with the modern era, and often take place in the major cities, or close to offices of government and seats of authority. The Cable Street riots, the Grosevenor Square anti-Vietnam protests, and, more recently, the poll tax unrest all took place in London. And yet it would be wrong to think that the capital was the only place where political conflict has occurred. Many violent insurrections over contentious political issues have taken place in far more peaceful, leafy backwaters. High Wycombe is no exception.

The suffragette movement began in Britain the late nineteenth and early twentieth centuries and was the struggle for women to gain the right to vote in public elections. Indeed, it was a struggle as a lot of people, mainly men, were of the opinion that women did not have the mental capacity to make serious decisions and should be barred from the political arena. Some of these men came from Wycombe.

From the early twentieth century until the First World War, almost 1,000 suffragettes were imprisoned in Britain for protesting for the right to vote. These incarcerations were for public order offences or failure to pay fines, although some were for arson.

The night of 9 March 1913 was dark and tempestuous. At Saunderton station, just outside Wycombe, the station master had seen off the last train, locked up for the night and made his blustery way home. At around 1 a.m. he was awaked from his bed by the clanking of bells. The combined fire brigades of Wycombe and Princes Risborough were rushing to Saunderton station; the place was ablaze. By the time they arrived the buildings were an inferno. Nothing could be saved, and all that was left were the blackened walls.

Who was to blame? Could it have been an accident? Or were there other sinister motives for its cause? On the same day Croxley Green station, near Rickmansworth, suffered a similar fiery fate. It was reported that just prior to the fire two women were seen walking away from the station.

However, at Saunderton, in the grey light of morning, evidence was discovered that pointed, undoubtedly to those responsible for the fire. Suspended from the station entrance railings were two placards upon which was scrawled, 'VOTES FOR WOMEN' and, 'BURNING TO GET THE VOTE'. The whole neighbourhood was agog, and all wondered where the next blaze would occur. They didn't have long to wait.

On the afternoon of 14 May 1913, two ladies from High Wycombe went to visit a female colleague in the village of Penn, just outside the town. Finding the friend not at home, they decided to pay a visit to the parish church. However, on entering the building, to their shock, they found the place on fire. Flames and smoke were coming from the organ. The vicar was roused and he came flying to the church where he climbed the tower and feverishly rang out the bells to raise the alarm.

Thankfully, the fire did not take a hold, and the Wycombe fire brigade easily brought it under control. Yet once again the question was asked: was it an accident or was it stated deliberately? Once all was safe at the church, the vicar examined a Bible that lay on a lectern. To his shock he saw a newspaper cutting with the words: 'Suffragette Incendiarism' and 'The Suffragette Cause'. It seemed that the women's movement had tried to set the church ablaze in protest.

As the two ladies who reported the fire made their way back to Wycombe via Tylers Green, they met a police constable and informed him that Penn Church was on fire and that the vicar requested his presence at once. The policeman immediately smelt a rat and, much to the women's shock, arrested them and marched them back to the church where they were detained as suffragette sympathisers and fire raisers.

However, local people who knew the two women tried to convince the constable that the ladies were of upstanding morals and would have been involved with such a heinous act as burning down a church. But the policeman would have none of it and the two, by now distressed, woman were not released.

Telephone calls were made. The husband of one of the ladies, a doctor, was called to vouch for his good wife's name, but to no avail. Local landowner Sir Philip Rose offered his own support for them. Still they remained in custody. It was only at 11.30 p.m. that they were free to go and the police convinced of their innocence.

Despite the two woman having nothing to do with the suffragette movement, following the fires and more unrest, a great women's suffrage pilgrimage was organised that would attract thousands of ladies from across the country to march on Parliament in London. Their route took them through Princes Risborogh, where their numbers swelled. One mother of ten children had cycled all the way from Bolton in Lancashire. After a short meeting in the town, the woman set off for West Wycombe where they were joined by supporters form Chesham, Aylsebury and Wendover. In West Wycombe defiant speeches were made and banners raised aloft: 'WE HAVE NOTHING TO FEAR FROM FREEDOM' and 'NO TAXATION WITHOUT

REPRESENTATION'. Then, in high spirits, they set off for High Wycombe. But the people of Wycombe were waiting.

Indications that trouble awaited the pilgrimage were first noticed when there was an exceptional demand for tomatoes and rotten eggs. Many of the towns youths were determined to have a bit of fun. As the ladies proceeded along Oxford Road, the crowds became so dense that it was all but impossible to carry on. Here they were greeted with waving handkerchiefs and cheers, but there were also boos and jeers. A meeting was planned at the fountain in Frogmore, but it was so packed as to risk the crushing and suffocation of all present. It was at this point that the town's hooligans let themselves go, and the shouting, hooting and throwing of missiles began.

A few courageous ladies tried to mount a platform to speak but were soon shouted down. Speaker after speaker tried in vain to shout above the jeering mob, but it was impossible. Councillors appealed for order imploring the crowd to 'act like Englishmen'. The crowd duly responded by launching a volley of tomatoes, rotten eggs and flour bags containing sawdust saturated with oil.

The women's banners were seized and ripped to shreds. A policeman was attacked and knocked off his feet, and finally the platform was stormed, forcing the suffragette speakers and their supporters to flee for their lives. The Wycombe mob then got wind

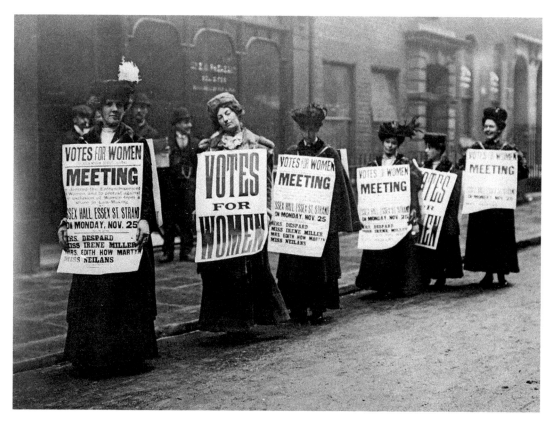

A suffragette campaign for votes for women.

of where the luggage and possessions of the women were housed and the building was attacked with windows being smashed. Finally, the police regained control of Wycombe's streets, yet it took until 11 p.m. to restore order.

What had started off as a peaceful protest march had ended in chaos in Wycombe. It was not one of the town's finest hours. For the suffragette movement it was just another struggle on the road to electoral freedom. In 1928 they achieved their goals and women were at last given the vote in Britain.

## Left to Rot on the Rye

On 2 January 1736, Mr Pontifax, a Wycombe farmer, left the Antelope Inn in the centre of town after spending the evening with his sister-in-law, the landlady Mrs Haydon. At around midnight he made his way home towards West Wycombe, but a mile outside the town he was accosted by two rogues who shot and robbed him. Pontifax was accompanied by his thirteen-year-old son, who managed to escape the killers and raise the alarm. The murderers were arrested some weeks later at a London Fair, and were tried at Aylesbury.

Left to rot on the Rye.

Early on the morning of 22 March 1736 they were brought by cart from Aylesbury to the Rye Common in Wycombe and were executed on an extraordinarily high gibbet. Such was the frenzy of interest in the event that the whole of the town turned out to view the spectacle, pushing over the wall of the Royal Grammar School in the rush to see the two men hanged. The corpses were left to rot and decay on the gibbet for four years before being cut down.

## The Black Death

There was no more deadly or devastating disease known to medieval Britain than bubonic plague. There was no cure, and once infected the victim had but days to live; in some instances hours. It did not discriminate between class, age, health or wealth. The only defence against its merciless spread was flight from ones fellow beings and neighbours into what isolation one could find.

Its symptoms could be said to have come straight from hells infirmary. Once contracted, black buboes, some as big as apples, would appear under the armpits and around the groin. A blackish, gangrenous pustule would form at the point of the infection. Dark blotches appeared on the arms, thighs or other parts of the body caused by haemorrhages under the skin. With the swellings came fever and an agonising thirst. In some case the sufferer would spit blood, and the sweat, excrement and breath of the unfortunate victims gave off an overpowering stench.

The genesis of the disease is almost as abhorrent as the symptoms. Plague was carried by bacteria that normally lived in the digestive tract of fleas, especially fleas of the black rat, a creature that was happy living close to humans. Periodically, the bacteria multiplied in the flea's stomach to such a degree that they caused a blockage. Then, while it was feeding, the flea regurgitated huge quantities of bacteria into its host. It was this terrifying disease that is said to have entered Britain in October 1348 at Weymouth in Dorset, and with ruthless rapidity made its way across England.

To what extent the Black Death of 1348–50 had on High Wycombe is hard to know. Those who tended to the sick were also educated enough to be able to read and write. Yet these people, who could have recorded the disease with written accounts, were themselves infected and soon died. We do know that the Black Death struck West Wycombe in 1349, causing heavy mortality and practically wiping out the village of Haveringdon, which stood on West Wycombe Hill.

During 1617 the plagued returned once more to High Wycombe and over 100 people were struck down with the disease. It was to cause more terror and mayhem in 1665 when it once again hit Wycombe, taking away ninety-six victims and a further 100 in 1666.

Some of Wycombe's neighbouring towns, such as Amersham, seemed to have escaped the worst of the plague and this may be due to the building of a 'pest house' just outside the town on Gore Hill in 1625. Those strangers coming to Amersham in times of pestilence and suspected of having the infection were isolated there together with any unfortunate townspeople who were thought to have contracted the disease.

With almost no medical knowledge of how to defeat the disease, patients were subjected to barbaric means of treatment including forced vomiting, urinating and bloodletting of

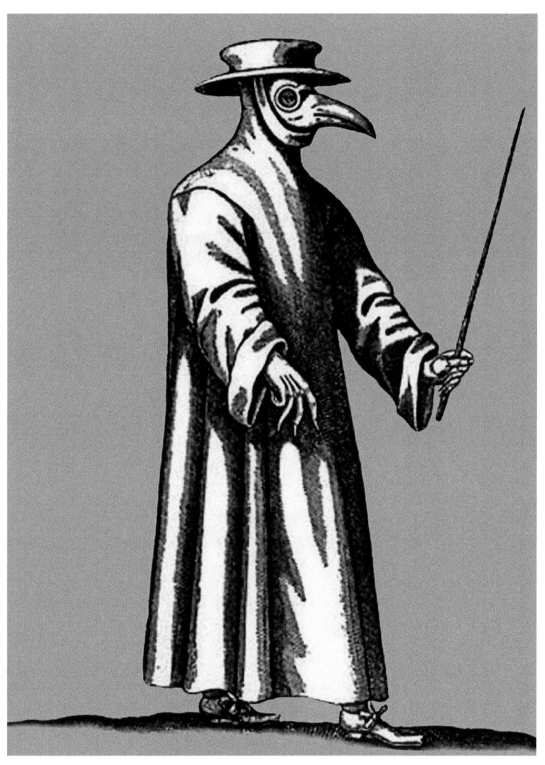

A doctor during the plague. The odd nosepiece was thought to prevent infection – it didn't.

A woodcut showing the horrors of the Black Death.

the ankles. Some of the sick would be wrapped in a blanket and drenched in cold water. Perhaps the most bizarre remedy was to cut open a live pigeon from breast to back, break open the bird and, while the poor creature was still alive, apply the flesh to the swellings on the skin of the patient. Given such treatments death's arrival would have seemed like sweet release. Yet even in death there was to be no relief. The unfortunate victims did not receive the dignity and peace of their own grave, but were unceremoniously thrown into hastily dug pits and covered with quick lime.

## DID YOU KNOW?

The death and slaughter of the First World War was on an unprecedented and unimaginable scale. We can gain some idea of the extent of the sacrifice and carnage when we look at the British army's most bloody day; the Battle of the Somme took place from July to November 1916. On the first day some 60,000 soldiers, approximately half of Wycombe's present population, were either killed or wounded. By the end of the battle five months later the losses had risen to 420,000 British troops, a figure comparable to the combined number of residents of Milton Keynes, Aylesbury and High Wycombe. If one adds the German and French dead to the casualty list, the cost of the Battle of the Somme accounts for the entire population of modern-day Buckinghamshire – around 900,000 deaths. The result the sacrifice of so many lives was the capture of barely 7 miles of territory.

# 5. When Wycombe Did its Bit

## Home Front

The Second World War, it can be argued, was in reality the continuation of the first, but with a twenty-one-year interval. The terms, conditions and reparations payments demanded by the victorious allies, together with the stock market crash of the 1930s, forced a defeated Germany into economic catastrophe from which a vengeful Adolph Hitler elbowed his way to power, and dragged the world, and Britain, into six years of bloody misery.

Unlike the 1914–18 conflict, the people of Wycombe would come to experience the Second World War up close and personal. By early 1940, Hitler's forces were poised to cross the English Channel. However, the Nazi leader would face a nation that had, over twenty centuries, forged themselves into a formidable fighting force determined to defend their island at all costs.

Thwarted in their attempts to knock out the RAF, the Germans resorted to bombing Britain's towns and cities. London suffered worse, yet Buckinghamshire was also to see its fair share of enemy bombs. From the capital to Wycombe came the evacuees escaping the Blitz. Not only children, but also hospitals, schools and factories were relocated to escape the nightly onslaught.

They had come to flee the bombs, yet still the enemy planes got through to deliver their deadly cargo. Although the German high command considered these raids as mistaken targets, their murderous explosive power was not lost on the people. Over 1,700 bombs and almost 4,000 incendiaries were dropped on Buckinghamshire between 1940 and 1944. Thirty-three people were killed and 200 houses destroyed. The most terrifying and devastating of these bombs was the V-1 rocket, known as the doodlebug.

In 1942, a V-1 rocket (flying bomb) aimed at London overshot its target and landed on Castlefield School in High Wycombe. Mercifully, no one was killed. During the summer of 1944 Wycombe suffered three further flying bomb attacks. On 19 June, a V-1 hit a sports field in Totteridge. Luckily, there were no casualties. On 5 July, a doodlebug hit Downley, injuring three people and damaging thirteen houses. The following month another V-1 landed in the Four Ashes, near Cryers Hill. In September 1944, just as the villagers of Lane End were sitting down to Sunday lunch, a V-1 rocket destroyed the local telephone exchange. In total twenty seven V-1 rockets landed on Bucks.

As mentioned above, the Luftwaffe considered these attacks to be mistakes. However, it is possible that if it had been known that Wycombe's furniture industry had been converted to wartime production then a more concerted bombing campaign of the town might have been launched.

If the doodlebugs had a nemesis, it was undoubtedly the Mosquito fighter-bomber. With a top speed of over 400 miles per hour, it could intercept the V-1s and shoot

them down. Today, it is considered one of the greatest war plane ever built. It was designed by Wycombe man Sir Geoffrey De Haviland, who was born in Magadla House, Terriers, High Wycombe. He would also design the Tiger Moth and the Comet, the first transatlantic airliner.

In 1944, it wasn't just the people of Wycombe who had to dodge the V-1 rockets. Apart from British troops, the town saw an influx of Polish and American service personal, as well as Italian prisoners of war. In 1942 the Air Ministry requisitioned Wycombe Abbey School to serve as the headquarters of the United States 8th Air Force. Some huts were built to house the troops on the lacrosse pitch. Some overseas soldiers didn't have the luxury of Wycombe Abbey as a billet. There were also Polish troops who had to make do with being stationed in Penn Wood.

One of the town's pubs became a favourite with the Americans – Flint Cottage, now opposite the train station. It was easy to find from Wycombe Abbey School, down one hill and up another, and it had a 'Yank's Bar' in the back. To make the US boys feel more at home, the legendary band leader Glenn Miller played a number of concerts at the school. In 1944 he played his last show at Wycombe Abbey before departing to entertain the troops in France. His plane took off from an airfield in Bedfordshire and was never seen again.

The doodlebug. They brought terror to Wycombe in 1944.

The Mosquito. Considered one of the greatest war planes ever built.

Geoffrey de Haviland, designer of the Mosquito.

## Refugees

Although some nations service personnel had arrived in Wycombe to train and prepare to take the fight to mainland Europe, there were others who were only to grateful to have escaped the clutches of the Nazis.

The Victorian vicarage next to St Margaret's in Hammersley Lane, Tylers Green, was never lived in by the wartime vicar Gerald Hayward. Instead, it became a Jewish hostel and home to scores of children seeking refuge from the horrors of the war. One of them, Bernd Koschland, was just ten years old when he arrived in Wycombe, alone and speaking only broken English. When he was eight, he was put on a train by his Jewish-German parents at Nuremburg as part of the Kindertransport rescue mission, which saw the safe passage of nearly 10,000 Jewish children to Britain. He never saw his parents again.

After a short stay in Margate and Staffordshire, he arrived at Tylers Green in 1941 where he attended the village school. He took and passed the eleven plus examination, which allowed him to go to the Royal Grammar School. Mr Koschland went onto London University and gained a degree in Hebrew and Aramaic, becoming a Jewish minister. He taught Hebrew and Religious Studies at the Jewish Free School and then the City of London School for Girls. He was a Jewish chaplain at the Royal Free Hospital in London, and during the Diamond Jubilee celebrations two years ago, he was invited to lunch with the queen to mark his charitable and community work. But he never forgot the love and peace he found in Tylers Green.

## A Doomed Wartime Romance

She was Lady Georgiana Curzon, the eldest daughter of the 5th Earl Howe, who lived at Penn House in the village of Penn Street just outside Wycombe. He was Roger Bushell, a dashing RAF pilot who's Spitfire was shot down in France in 1940. He escaped from three prisoner-of-war camps before being recaptured and, while in hiding, sent vital information back to Britain through coded letters, including information about the development of V-bomb rockets.

They had met in 1934 when she was twenty-four and fell deeply in love. However, her father, unimpressed by Bushell's social standing – he was a lawyer born in South Africa – did not approve. Consequently, Georgiana was forced to marry the son of a motor-racing friend of Earl Howe, but it was a disaster. She obtained a divorce in 1941 after her new husband admitted adultery with her stepmother.

Despite losing her, Roger Bushell was telling other prisoners that 'Georgie' was his true love whom he would one day marry. Tragically, they were never to meet again. Bushell was one of fifty escapees murdered by the Gestapo in 1944. The story was told in *The Great Escape* in which Richard Attenborough played the part of Bushell.

Lady Georgina could never accept that Bushell was dead. For years she placed an 'In Memorium' in *The Times* on his birthday ending with the words 'Love is Immortal' and signed 'Georgie'. She ended her days in a home for the mentally ill and on her gravestone in Holy Trinity, Penn Street, are two lines of poetry by Tennyson: 'Oh for the touch of a vanished hand, and the sound of a voice that is still.'

*Above*: Lady Georgina Curzon and Roger Bushel. Their love was doomed.

*Left*: Richard Attenborough played Bushel in the 1963 movie *The Great Escape*.

## Hitting Back

If Britain couldn't hit back at the enemy through military means, there was always covert action. The country houses of Bucks played a vital part in the intelligence war against Nazi Germany. Hughenden Manor, once the home of Victorian Prime Minister Benjamin Disraeli, became station 'hillside' It was here that recognisance photographs of the Ruhr dams were analysed and helped formulate the plans for the famous dam buster raid on the Ruhr Valley in Germany in 1943.

Although covert actions would thwart and delay the enemy, the real victory would only come with the combined force of army, navy and air force. The men of Bucks had already shown their metal during the withdrawal to Dunkirk. In May 1940, the 1st Bucks Battalion were given the job of defending the Belgium town of Hazebrouck. The 1st Bucks were made up of companies from across Buckinghamshire including Aylesbury, Amersham, Wolverton, Marlow, Slough and High Wycombe. During the retreat to Dunkirk, they were confronted by German Panzers and thousands of Nazi Stormtroopers. The 1st Bucks were armed with only rifles and grenades, yet they managed to halt the advancing Germans for a crucial forty-eight hours allowing the British Expeditionary Force time to evacuate more men. The defence of Hazebrouck in 1940 was even commended by the German high command as 'truly worthy of the highest traditions of the British Army'.

Yet, the one wartime operation all Wycombe people can be proud of is that which was carried out by the men of the Ox and Bucks Light Infantry on the night of 5 June 1944. A force of 181 men, led by Major John Howard, took off from southern England in six gliders to capture Pegasus Bridge over the River Orne. The force was composed of D Company, 2nd Battalion, the Ox and Bucks Light Infantry. Their D-Day mission was

Pegasus Bridge in Normandy. It was stormed and taken by men of the Ox and Bucks Light Infantry.

to take and secure the bridge and prevent German armour from crossing the river and attacking the eastern flank of the allied landings on Sword beach.

Just after midnight on 6 June, five of the Ox and Buck's gliders landed as close as 47 yards from their objectives, taking the German defenders completely by surprise. Within ten minutes they had taken and secured the bridge. In the short fierce battle they lost Lieutenant Den Brotheridge, a onetime council employee at Aylesbury, who was killed in the first minutes of the assault. The heroic lieutenant became the first member of the invading Allied armies to be killed in action on D-Day. He was posthumously awarded the Military Cross.

Sir Winston Churchill had warned the Nazis that the British people would fight in the fields and in the streets and in the hills; we would never surrender. He was proved quite right and the men of Wycombe did their bit.

# 6. Surrounding Secrets

Many of the readers of this book will no doubt be from High Wycombe. But there will also be those who were born in the town, yet have now migrated to surrounding locations. Like Wycombe, these unassuming neighbouring places also have their secrets.

## Chesham

He was a Chesham man, stood over 6 feet 7 inches tall, was a religious fanatic and from 1642–49 served in the Parliamentarian army during the English Civil War. It is said he was sentenced to death by Cromwell for a breach of discipline. The sentence was never carried out, but while in Colchester Prison he received a blow on the head, and thereafter his behaviour became somewhat strange.

   He led a life of celibacy and propounded the theory that it was sinful to eat flesh or fish or drink alcohol. He dressed in sackcloth, existed on three farthings a week and lived on a diet of dock leaves and grass. During his life he was three times imprisoned for witchcraft and was often put in the pillory or stocks.

The mad hatter of Chesham.

Despite his odd behaviour, he returned to Chesham and opened a hat shop. So successful was his enterprise that he became one of the town's richest men. In 1651 he sold his business, gave all his money to the poor and took to the life of a hermit, living in a hut in Ickenham near Uxbridge. He died aged fifty-nine in 1680, forgotten and unmourned. His name was Roger Crab and he was the inspiration for Lewis Carol's creation the Mad Hatter from Alice in Wonderland.

In 1996, builders in Chesham unearthed part of a fifteenth-century building in the high street that is thought to be the site of Crab's hat shop.

## Marlow

Apart from Bram Stoker's bloodsucking creation, Count Dracula, perhaps the other most well-known fictional monster in literature is *Frankenstein*, written by Mary Wolstencraft Shelly in the early nineteenth century. In 1816, Shelly, together with her husband, the poet Percy Byshe Shelly, and their friend John Polidari, were holidaying on the shores of Lake Geneva at the rambling villa Diodati in Switzerland. During their stay the weather was particularly foul with weeks of incessant downpours. Confined to the gloomy rain-lashed villa, the companions were inspired to compose gruesome blood curdling tales. It was Mary's composition, inspired by a nightmare, which proved to be the most disquieting, and has since become a classic of gothic horror.

Shelly's tale of the mad Victor Frankenstein and his monstrous creation would ultimately be the inspiration for numerous plays, books and almost a thousand feature films. Two hundred years after its publication it still has the power to frighten and shock. Yet, even though the genesis of Frankenstein was conceived on the gloomily, romantic shores of a Swiss lake, it was completed in the rather more mundane location of West Street, Marlow, Bucks. When the Shelly's returned to England in 1816, they were encouraged to settle in Marlow by the writer Thomas Love Peacock, who would later write his gothic novel *Nightmare Abbey* in a nearby house. Marlow would appear to be a most appropriate location for the completion of Shelly's tale of an insane doctor's desire to create life. From 1758 until his death in 1776 William Battie, an eminent physician specialising in mental illness, lived in Court Garden House. The expression 'batty' is believed to have originated from his work with the mentally ill.

The phrase 'truth is stranger than fiction' is often applied to those incidents and episodes which leave the reader open-mouthed and scratching their head in disbelief. The following account demonstrates this only too well.

One morning in 1832 a resident of Marlow said goodbye to his wife as he went off to work. He told her he would return that evening and that they would enjoy a good dinner together. The man's wife was happy, healthy and in good spirits as she bade farewell to her husband. However, when the man returned that evening, he was surprised to find the house empty and his wife not at home. Soon, distraught and anxious, neighbours came to the man's home to tell him the devastating news that his wife had died that morning and had to be hurriedly buried.

The distressed man could not believe that his true love had been taken from him so quickly and without warning, and in anguish, he rushed to the churchyard where

Mary Shelly wrote part of *Frankenstein* in Marlow.

she had been laid and desperately dug down to the coffin and opened the lid. To his astonishment he perceived signs of life, which was soon confirmed when the woman sat up in the coffin to the great joy of her husband. The woman recovered and both returned home, much to the amazement of the locals. Incredibly, that same night, the woman gave birth to a child.

## Penn

The village of Penn, near Wycombe, is a good example of an ordinary location with some extraordinary connections. Sir William Penn, founder of the city of Philadelphia in the USA and after which the state of Pennsylvania takes its name, claimed Penn as his ancestral home. His sons lie within the church crypt, and Sir William, his wife and family lie in nearby Jordan's village churchyard.

Penn Church is also the last resting place of David Blakeley. He was murdered by Ruth Ellis, the last woman to be hanged in Britain. Her grave is in nearby Amersham churchyard. Penn Church also contains the graves of the parents of Soviet spy Donald MacLean. He, along with Guy Burgess and Kim Philby, betrayed Britain's military secrets to Russia just after the Second World War. On discovery, all three defected to the East. When MacLean died in 1983, his will requested that his ashes be returned to England and scattered on his parent's grave in Penn churchyard. Other former residents of Penn include the actor Stanley Holloway, poet Walter De La Mare, librettist W. S. Gilbert, and Louisa Garret Anderson, the daughter of the first woman in Britain to qualify as a doctor.

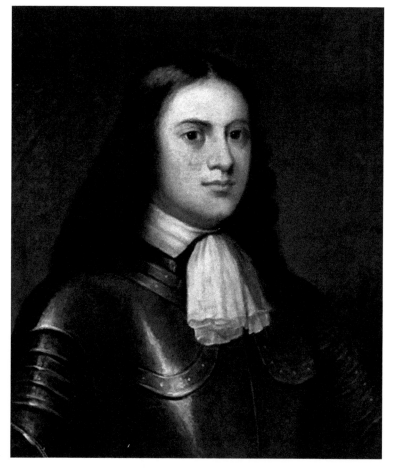

Sir William Penn, founder of the state of Pennsylvania and city of Philadelphia.

Penn parish church.

## Amersham

In the early sixteenth century, Amersham was a hotbed of Lollardism. The name Lollard was a contemptuous term for a follower of John Wycliffe, a fourteenth-century theological reformer who translated the Bible into English and was a vigorous attacker of the abuses of the Church of Rome. Wycliffe had many opinions on the way the church should be run, but his main objection was that it was forbidden to read or possess the Bible in an English translation. When Henry IV usurped the throne in 1399, he passed a statute which gave authority to the bishops to punish those who were Dissenters. If people were found guilty of heresy, which included owning and reading a Bible in English, they would be condemned to burn at the stake. Amersham saw a dozen or more people connected with the Lollard movement executed between 1414 and 1532. In 1414 four men from Amersham and one from Great Missenden were executed for adhering to Wycliffe's heretical views. Curiously, Wycliffe himself died peacefully in 1384, but his followers were to be subject to much persecution. The Lollards referred to themselves as the 'just fast men' or 'Known Men', because of their steadfast allegiance to God. However, following the executions of the Amersham men, things became quiet and many of Wycliffe's supporters were forced into hiding.

Around 1500 there was a Lollard revival in the Chilterns, and while most sympathisers recanted their beliefs, others refused and went to the stake. Among those charged and found guilty was William Tylsworth of Amersham. He refused to recant, and in 1506 was sentenced to be burned to death. The savagery of the time, and the hatred felt towards Dissenters, is reflected in the fact that Tysworths daughter Joan was made to light the fire herself.

Other Amersham Lollards who suffered martyrdom for their beliefs were Robert Cosin, burned at Buckingham in 1506; Thomas Chase, strangled and beaten to death in a wood near Wooburn in 1514; and Thomas Mann, burned at the stake in London in 1518.

In 1521 John Longland was appointed bishop of Lincoln and confessor to Henry VIII. To gain favour with his new royal master a fresh round of heresy trials was embarked upon.

In that same year six men and one woman from Amersham were put on trial in St Mary's Church for Lollardy. None recanted their belief, arguing that they had the right to read and interpret the Holy Scripture and to worship God according to their conscience. They were found guilty and taken from the church to a hill high above the town where each was burned at the stake. The most savage and heartbreaking of the executions was that of John Scrivener. His young children were forced to light their father's fire.

Thomas Harding, the last of the Lollard Martyrs, was burned at Chesham in 1532. As the flames licked higher and the poor man writhed in pain, one of the horrified spectators mercifully took pity on the wretched soul and threw a log at him that 'dashed out his brains', sparing him the prolonged agony of his fiery end.

In 1931 a memorial in the shape of a giant, granite obelisk was erected on a hill overlooking Amersham to commemorate those who had suffered for their religious beliefs. It stands just 100 yards from where their execution pyres were lit and looks over a town and countryside mostly unchanged since the sixteenth century; a final view which must have lingered in the eyes and minds of those martyrs back in a savagely intolerant time.

William Tylsworth was burnt at the stake in Amersham.

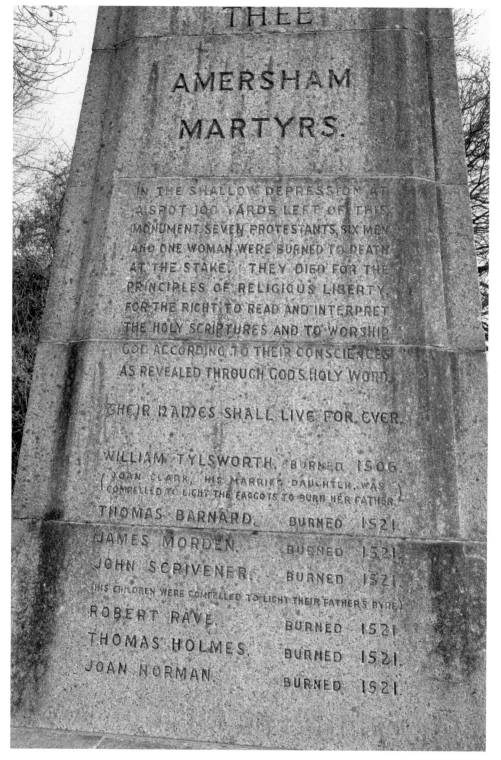

The names of the martyrs on the memorial on the hill outside Amersham.

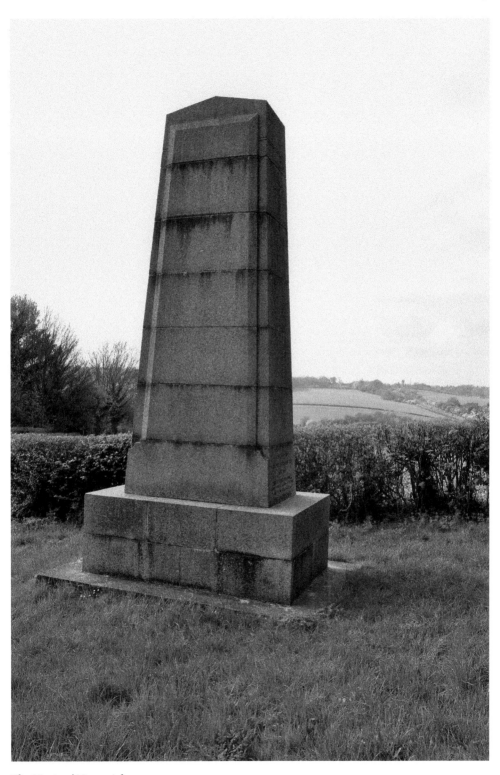

The Martyrs' Memorial.

# 7. The Changing Town

A Series of Then and Now Photographs

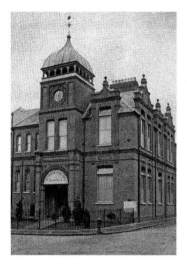

The arts school in Frogmore in 1893. It was converted to swimming baths in 1929, and in 1949 it became a theatre. Today it is a dental surgery.

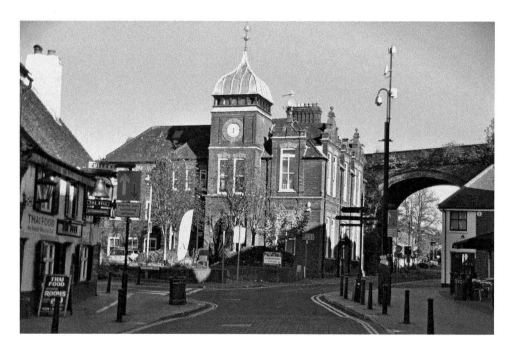

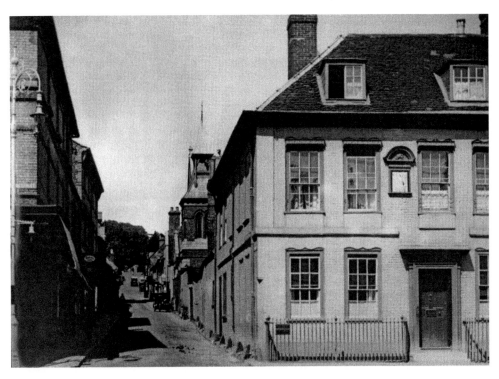

Crendon Lane in 1937. Today, the scene is unrecognisable.

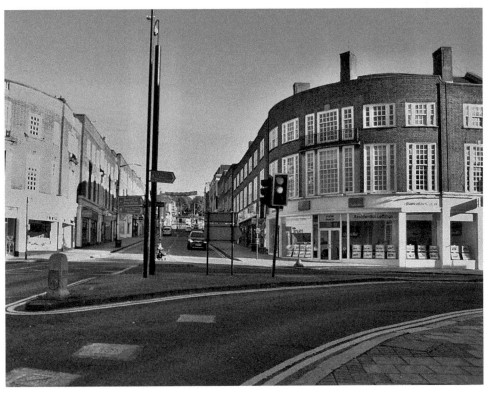

Frogmore in 1905. It was here in 1913 that a suffragette meeting turned into a riot.

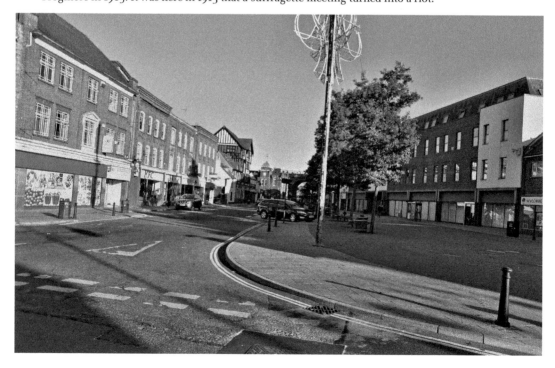

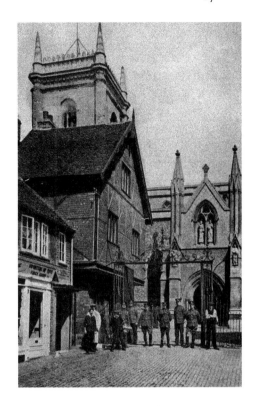

Soldiers and civilians stand outside the gates to
All Saints Church in 1914.

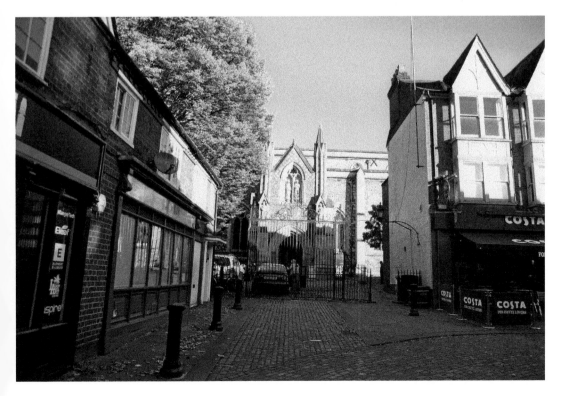

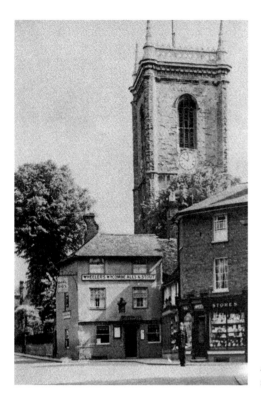

A sunny morning in 1930s Wycombe and the same scene today.

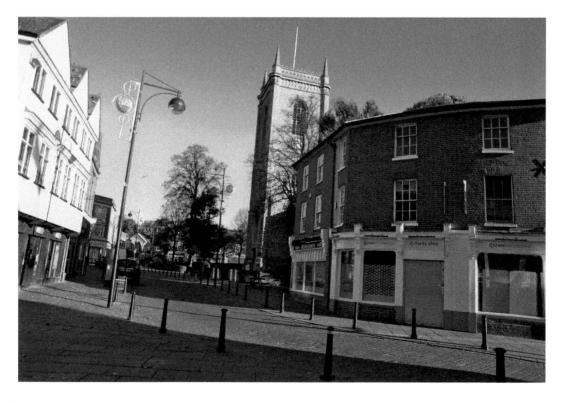

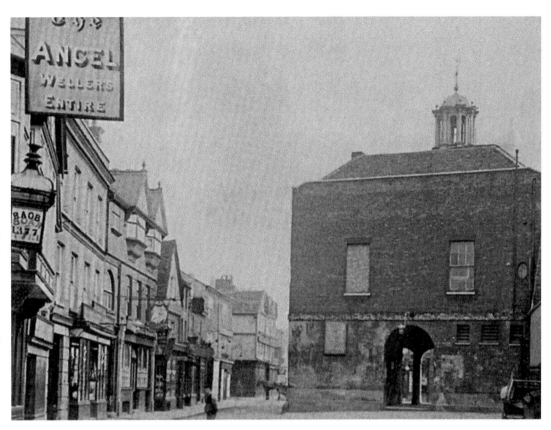

St Paul's Row was one of the oldest parts of Wycombe. Today only the Guildhall survives.

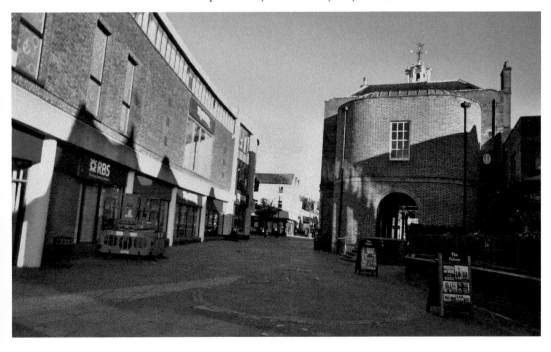

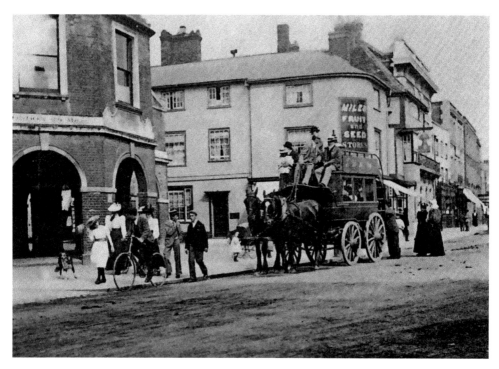

Passengers alight form a bus in the high street. Happily the scene hasn't changed that much.

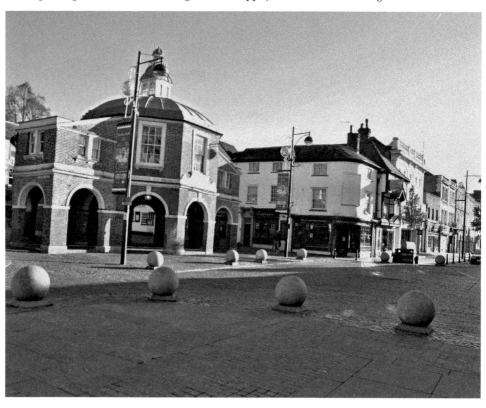

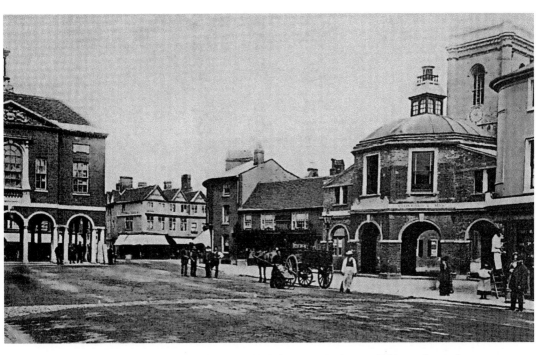

Another view looking across the high street, which has remained remarkably unchanged.

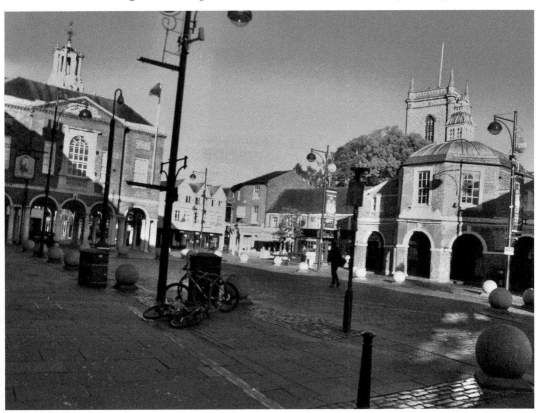

The Antelope Inn. This was the birthplace of
the Royal Military College. Today the scene is
greatly altered.

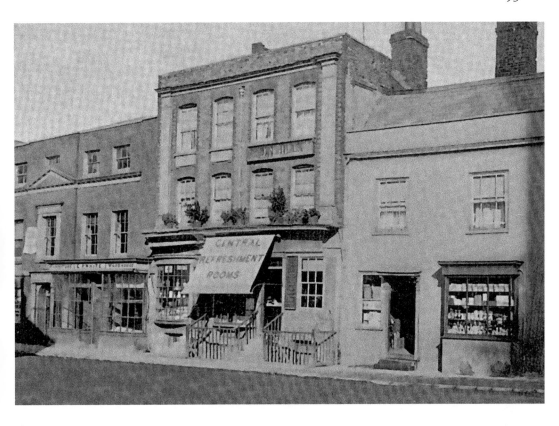

Church Street in 1895 and
the view today.

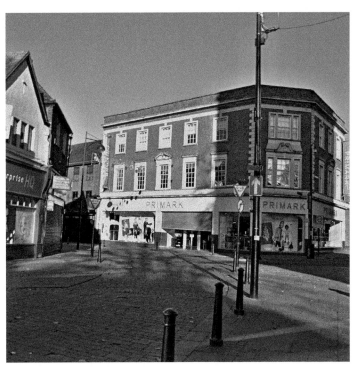

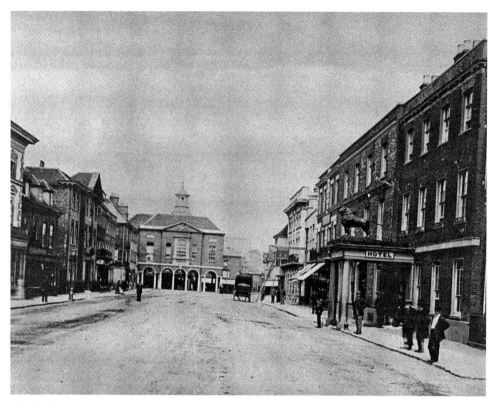

The high street in 1900. One wonders if the people posing for the photographer could ever dream what Wycombe would be like 100 years in the future.

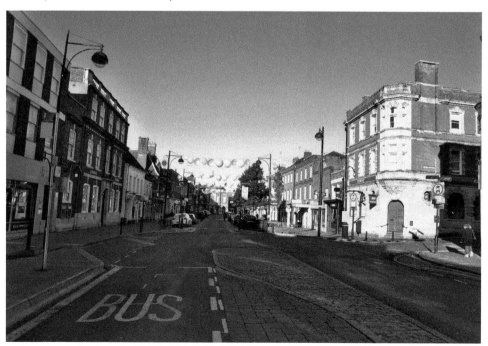

# Acknowledgements

Many thanks to Jackie Kay, Dave and Deb Lee, Illya (at the Gate), Tom Reece-Kaye and Max Hadley, the many Facebook correspondents who provided information, and most of all, my long suffering wife Sue. Thank you for your patience, beer and sandwiches.

# About the Author

Eddie Brazil was born in Dublin in 1956. He is a writer, photographer and paranormal investigator. He is co-author, with Paul Adams and Peter Underwood, of *The Borley Rectory Companion*, and *Shadows in the Nave: A Guide to the Haunted Churches of England*. In 2012, with Paul Adams, he wrote *Extreme Hauntings: Britain's Most Terrifying Ghosts*, and in 2013 he published the first ghostly guide to *Haunted High Wycombe*.

He is also a guitarist, and in 1983 wrote the theme music to the British comedy movie *Expresso Splasho*, which featured Gary Oldman and Daniel Peacock. Eddie lives with his wife and daughter in High Wycombe.

# Also available from Amberley Publishing

CHARLES CLOSE

# AYLESBURY

THROUGH TIME